MILTON GLASER DRAWING IS THINKING

MILTON GLASER
DRAWING IS THINKING
INTRODUCTION BY JUDITH THURMAN

OVERLOOK PRESS, WOODSTOCK & NEW YORK

First published in the United States in 2008 by
Overlook Duckworth, Peter Mayer Publishers, Inc.
New York, Woodstock, and London
www.overlookpress.com

NEW YORK
141 Wooster Street
New York, NY 10012

WOODSTOCK
One Overlook Drive
Woodstock, NY 12498
(for individual orders, bulk, and special sales,
contact our Woodstock office)

LONDON
Gerald Duckworth & Co. Ltd.
Greenhill House
90-93 Cowcross Street
London EC1M 6BF

Cataloging-in-Publication Data is available from the Library of Congress

Manufactured in the United States of America
First Edition

US ISBN: 978-1-58567-994-2
UK ISBN: 978-0-71563-834-7

INTRODUCTION BY JUDITH THURMAN

I recall the day that my kindergarten teacher passed out the primer for our first reading lesson. Leafing through the pages, I was cruelly disappointed. It was just a picture book, and the only written word appeared about halfway through. I doubt there was a child among us who couldn't parse the four block capitals on a familiar hexagon: they spelled "Stop!"

Readers are initiates of a language. They have been conditioned to accept, beforehand, whatever arbitrary meaning has been assigned to the symbols on a page. A conventional primer lays the tracks for that unquestioning acceptance in a child's neural circuitry like a stylus grooving the stone of a tablet. It creates channels of perception that are necessary for a shared sense of what is real—or, more precisely, of what is agreed to be real. Without names, and without definitions for objects, actions, and values, no community can perpetuate itself by transmitting its culture to a new generation. In time, however, those channels tend to become ruts, and the magical, polymorphous world that we surrender to tidy abstractions when we learn to read loses its vibrancy. To perceive something is to recognize it. But to recognize something is not necessarily to perceive it. In *Drawing as Thinking*, Milton Glaser invites us to contemplate that distinction.

The absence of text is, in part, the artist/author's calculated refusal to provide a narrative channel—the signposts on a trail, the audio-tour at an exhibition, the plot of a thriller, the exit lights—that predetermine our experience. This is a journey, in other words, but our guide won't tell us where we're going, and every reader has to reach his own destination. Glaser's work in this book has the changing rhythms and tonalities of a piece of music. The melodic lines of

his imagery rise and fall, but they are also sometimes disrupted, so that you can't anticipate their momentum (the tension between inevitability and surprise is one of the qualities that makes a pattern of shapes, sound, gestures, or words stirring). From page to page, you become aware of connections and affinities among the drawings that face or follow one another in Glaser's carefully considered sequence, some more obvious than others. Like chords, they are governed by the laws of harmony: a coherence the mind grasps without tutelage. That inner logic is the hallmark of a master's work in whatever genre. However one defines beauty, its spell holds distraction at bay, and creates a sanctuary from which randomness is excluded. In that space out of time, we have, however briefly, the chance of becoming present to ourselves—and one with the art.

An artist, however, can't induce a state of mindful repose in an unmindful beholder, and even though there is no right or wrong way to digest Glaser's lines and colors--no cumulative or progressive meaning—*Drawing as Thinking* is, in its way, also a primer. Its title pays homage to the work of Frank Wilson, a cognitive neurologist whose studies of the hand and brain posit a connection between the manual dexterity of homo habilis and the evolution of homo sapiens' unique capacity for symbolic representation. (According to Wilson's research with living subjects, the hand does more than execute cerebral commands—it plays a prime role in their orchestration.)

In Glaser's view, art is one of, and perhaps the most important, of our species' tools for survival. Think of it as a whetting wheel invented by our earliest ancestors to hone their consciousness of the natural world. Any reader who

has, like those nomads and cave painters, spent time in the wilderness will appreciate this theory. Our senses evolved as a sublime intelligence-gathering operation minutely attentive to every scent, rustle, and shadow in a landscape. Keen senses bring us intense pleasure and, at the same time, vital information. Dull or complacent ones cease to register unprejudiced impressions, and in doing so, weaken our defenses. A virtuoso of the hunt never relaxes his quest for attunement with an elusive quarry, but neither does a sage or a poet, and when we speak of love "losing its mystery," we are are, with a cliché, describing our own lazy surrender to sensory domestication. Art may be a civilizing force (Glaser's imagery alludes both with reverence and impiety to masterpieces of the Western canon), but by unsettling our expectations, and confronting us with fresh mysteries, it renews our wild edge.

That drop-edge of awareness is Glaser's starting point for this adventure, which is a radical departure from the graphic and product design, illustration, and political iconography for which he is famous. The boundary between "applied" and "fine" art is a bit specious (and Occidental: it never existed in Japan, or among tribal artisans), especially in the case of an artist like Glaser, who navigates the marketplace of our visual culture, but without compromising his ideals. Previous collections of his work, however, conveyed a legible message. Here, Glaser challenges us to embark on a deep, leisurely meditation without stop signs or, indeed, without directions or imperatives of any sort except, perhaps to think about what the Buddhists mean by a "beginner's mind." For that, no words are necessary. Open the book to any page and, rather than searching for a way to interpret what you are seeing, just sharpen your eyes.

INTERVIEW BY PETER MAYER

P February 17, I think it is. A Saturday in New York.

M It's actually the 24th.

P Milton, we've had two long sessions over a great many years. I've asked you many questions, and there is quite a bit of consistency between what you said in *Graphic Design* and what you later said in *Art is Work* about the role of the designer. You had a lot of chances in those pages to talk not only about individual pieces of yours, but also about other artists' art history, what and who have influenced you, and to air questions you have regarding so-called high art and so-called applied art. The first two books were displays, to some extent, of periods of your work. But this is a very different book, a much more personal book. Again, a great many images have been taken from your work, although you have sequenced them to bring out certain aspects of, let's say, the title. Titles are quite important to you. The second book was called *Art is Work*. Now we have *Drawing is Thinking*. Perhaps you can speak to why the book is the way it is; why it is so personal and important to you.

M *Drawing is Thinking* has a slightly different intention than the two previous books we did together. It is a showcase, inevitably, because every time you present your work, to some degree it is a showcase. It has less of a narrative structure in terms of trying to explain what each of the images mean and linking them to functional intentions. It deals more abstractly with the purpose of art in a way which I did not address before. In the other two books, which are largely didactic and aimed at practitioners and students, my intent was to describe the background and the thinking process for each of the examples shown so that the method of arriving at a design solution became clear. Here, outside of the fact that, at the end of the book, we describe what these drawings were originally created for, I have a very different intention. Most books on art or design organize the work as a kind of catalogue, either chronologically or by medium or subject matter. In *Drawing is Thinking*, the images are arranged in a sequence intent on provoking the mind to action. My intention in creating this book was to fashion a kind of musical experience, one in which each image anticipates what is to come and relates to what has appeared before, much as a melodic line does. I am hoping to achieve a non-descriptive experience.

Art seems to affect us beneath the surface of our rational or logical mind. It basically moves the mind to action on a different level, one that is more profound and less describable. In this book, the sequence of images is also related to a kind of internal dialectic. The picture on the

left and the picture on the right of each spread have something in common, although it may not be obvious.

My long-standing interest in ambiguity comes out of the fact that our deepest feelings are rarely raised to consciousness. I'm fascinated by the fact that current neurobiology study suggests that there may not be any reality out there until the brain creates it. What is most compelling to me about the act of drawing is that you become aware, or conscious of, what you're looking at only through the mechanism of trying to draw it. When I look at something, I do not see it unless I make an internal decision to draw it. Drawing it in a state of humility provides a way for truth to emerge.

P Would you say that the arrangement, or sequence, and the very selection of the images make the argument that is implicit, or, you might say, explicit, in the title ?

M Yes, the title actually is a description of what my hope is in the book. Drawing can be considered a form of meditation. Meditation involves looking at the world without judgment and allowing what is in front of us to become understandable. Art, in fact, may be the best way we have to experience truth or what is real.

P Would you say that about drawing even more than, let us say, music or works that may be written?

M Well, I think all of the manifestations of art have something in common. My belief is that they are part of the survival mechanism of our species. I believe that art is a form of mediation for both maker and witness and that, like meditation, art makes us attentive. If you say that the aim of art and meditation is to produce attentiveness and quiet the mind so that it can discard pre-existing ideas in order to see what is real, then we can say all of the arts share this. They help us to survive by encouraging attentiveness.

P How might the reader approach the book? How can you be sure the readers will follow your images and comprise the narrative you intended, the trajectory and point of view? Aren't you, in addition to being an artist, also a teacher? You're in the habit of quite clearly explaining things. It's what you have done at the School of Visual Arts for years.

M You raise a number of interesting questions, including the one implied by the use of the word "reader." This is not exactly a reading experience. People will try to *read* this book. And they will be disappointed because this is not a book to be read.

There is a sequence, but what you have to do, in this case, is suspend the inclination to read. As I said before, narratives will occur, but your unconscious will invent them. I put these drawings together, but not with the intent of creating a comic strip or a visual novel. I've always loved comic strips because of their way of combining narrative and visual material. Here, the sequence is not obvious. The rhythm changes. There are some things that are clearer than others. You see two portraits; one is fully realized, the other is suggestive. You'll see two drawings of a sun spotted-lawn and then you'll see some things that don't make sense immediately. I make the assumption that everything in human experience is connected in some way. Every image is connected; every human is connected. Even if you wanted to avoid doing so, you could not create a series of images where connectedness was not, in some way, a part of the experience of viewing it. So, part of this exercise is the inevitability of connectedness. The truth of the matter is that the "reader," if I can use that word, might not understand those connections immediately because they are not overt. However, connections are made by that part of the mind that is susceptible to ambiguity, to imagery that is not literal. We are so much smarter than we know we are. We understand so much more than what is obvious.

Take any two objects in your house, perhaps a toothbrush and an orange, and put them on a table. You will discover that, by some uncanny means, they are related. That is true of everything else in our universe. You asked before, "How do I know if they'll get it?"

P Different people bring different things to the table of their experience. There must be different perceptions that people will "get" because you're taking them visually and with comment down a path.

M Well, there are several presumptions made in what you've said. First of all, each person perceives every artwork somewhat differently. You're quite right that when the path is unfamiliar, people will have resistance to it. People do not like unfamiliar experiences; they tend to eat the same foods, watch the same TV shows and so on and so on. If a book is different, then its central structure maybe resisted by those people who don't like the experience of being without guidelines.

P What do you want to achieve, in having created this work? The images in it are not new, but the book itself is a totally new work. If the book is an aggregate of the images and their sequencing, then one might ask the question: Who is this sequence for? We agreed early on that this would be a very personal book. Is this a book that you see as for yourself?

M You know, every time I speak to students, they always ask, "Do you do any work for yourself?" The presumption beneath that question is that since one works to assignment, the work is not for oneself. My view is that *all* the work I've done is for myself, and it also involves accommodating either a personality (the client) or problem that has to be solved. Such is the nature of the design profession.

My work is always for an audience because I want people to see it. But, here, what I want them to see is something other than a series of solutions to individual problems. There was a precedent for this idea in a show done by a guy named Aby Warburg, an art historian, in 1929. He put a random selection of paintings and news clippings together in an exhibition, combining items such as a news clipping of the Emperor of Japan committing hari-kari in the middle of two Renaissance paintings. His aim was to create a visually disruptive exhibition that made people think about what they were looking at. That notion is not very far from the objectives of this book. I get closer here to my attempt to create attentiveness than in any single work that I've done. I have always been aware of the need to provoke the mind when communicating ideas because that is the only way that you prod someone into understanding anything. That is why ambiguity is such a useful tool. In *Drawing is Thinking*, it is the cumulative sequence that I am interested in. It is kind of a cross between a comic strip and a film and a meditation.

P I remember I came to you with an idea that was superficially like this, but in actuality is really not like this at all. You have taken that idea and changed it to a very large extent so that it is now your idea. I want to recall for a moment what I was trying to see you achieve. It always bothered me that I saw in your work an extraordinary technical and art historical range on behalf of an aesthetic but purposeful nexus or message that someone came to you with, but your work was usually appreciated in terms of *message*. And I see these qualities of yours—skills and attitudes and strong feelings about politics, music, food, etc.—existing separately from the message.

I wanted to celebrate the pure art that underlies so much of your work, which is sometimes disguised by the fact that you work with and within a great number of styles. I proposed a book of pure illustration. I wanted to remove all type; it still would have been a display book, but excepting for the most aesthetic arrangement of the images, there wasn't going to be any particular message—like "drawing is thinking"—in it. The examples chosen would illuminate the visual aspects purely. Instead you chose something much more sophisticated and personal. Here you are picking examples to purposes you do not comment on.

M Well, in my memory as well, you approached me with the idea of publishing a book of drawings and defined that book as a collection of previous work.

My problem with that idea was how not to be defensive by presenting artwork in a conventional catalogue, either by medium or date or subject matter. I wanted the book to bypass the tedious issue of fine verses commercial art, which serves no one and creates infinite confusion.

P I wanted them to see your work in terms of color, form and space, line, all those aspects that are so often irrelevant, to eliminate the element of "message."

M My conviction is that a standard presentation of these works would make it impossible for any viewer to look at these drawings with any idea other than that these are the works of a commercial artist, and they are very nicely arranged. As we know, context affects everything. If no one had ever heard of me, it would have been very appropriate and nice to have simply published a book of drawings labeled *Drawings by Milton Glaser, 1950 – 2008*.

The point is that because I am well known, the audience would think, "Oh, the old geezer is trying to show he is an artist." The history of my work and its context makes it impossible to look at this without those references.

P How is the understanding of the object changed by the process of rendering it in another form—say, in drawing it?

M We learn from everything and every experience informs every other one. If I do a little piece of architecture for an interior, that becomes a part of my understanding of what I do for drawings.

If I do a piece of typography, for instance, my idea of what the form is might come from the shape of the human head. Professional life is characterized by specialization. I've tried not to define myself too narrowly. I love Horace's definition of art's purpose: "to inform and delight." But the idea that art makes us attentive is a new idea for me. Although I always believed that art was linked to survival in some way, I did not know quite how. When I say that attentiveness is a condition essential to the human species, I believe the principle applies to cave paintings as well as Picasso's *Guernica*.

P Would you say that expressing oneself visually is inherent in all people?

M I would, but it's not my idea alone. Frank Wilson, who wrote a splendid book on the hand

and the brain, says when you interrupt a child's drawing activity—in other words, when you stop them from drawing during their developmental years—the brain does not develop the same way.

P Is drawing central to designing? Is there a correlation?

M What is essential is the relationship between the hands and the brain. This could be encouraged by any activity where the brain and the hand are unified in an attempt to understand what is real. In my case, drawing forms a very important component of my understanding. However, in Africa, since they don't usually draw, carving and weaving would probably produce a similar effect. The task is to understand what you're looking at.

P You're saying that the activity is basically a primitive instinct.

M That's how we learn. We learn through movement.

P It seems that every great artist, regardless of the style he later develops, draws initially.

M At a certain point, in the history of art, the idea of depicting reality became irrelevant. With the advent of Kandinsky, at the turn of the century, and Cézanne, and Picasso, the objectives of art dramatically changed. In that regard, you could make a case that Cézanne was the most real of all artists, including everyone from the Renaissance through the nineteenth century, because what he was doing was closest to the way we perceive optically, before the mind imposes history and experience on what we see. There is a very wonderful book by Jonah Lehrer called *Proust was a Neuroscientist*. In it, Lehrer explores what Cézanne's contribution has been to art and makes this great point about that time: for artists, the ability to draw accurately was essential. But in our time, once we got over the idea that the object shown had to be an accurate depiction of what you were looking at, that objective collapsed. All representations are abstractions. At the same time, the need for drawing as a discipline did not go away.

Even Vermeer, the most lucid of artists, is full of ambiguity. Today we have contempt for a certain kind of nineteenth-century skill because, despite its virtuosity, it doesn't make you attentive. There are too few connections that need to be made in the mind when viewing it .

When you look at a Vermeer and read in an art history book that the reason the work is successful is the compositional balance of yellow and blue, you are being informed of nothing. The reason you are responsive to a Vermeer is because he has moved your mind. Cézanne showed us

that in a bowl of apples, and every artist does this same thing in his own way.

P Does there need to be technical facility at drawing, in that area of descriptive drawing, that we perhaps don't prize today as highly as we did a long time ago? At a time, that was essential equipment for every artist.

Traditionally, skill has been one of the components of people who made art. It's hard to imagine Vermeer or Mozart without their technical skills. Now, in the world of the computer, there seems to be a great loss of basic skills.

M The computer does things that people may not be able to do, but at a price. There is something about the struggle and the energy used to make something that is being compromised. A teacher of mine once said that every object contains the energy of its maker. For want of a better explanation, that is what we see in objects, the energy of the maker. It remains constant; the object may be valued, or not valued, but the energy is always there. It cannot be destroyed. The act of making it has basically encapsulated that energy.

P Are you avoiding saying, what I think must be part of your point in *Drawing is Thinking*, that technical skill at drawing, more or less in a realistic style, is essential to the artist?

M Well, you need to have enough skill to be able to express your idea. How much skill that is varies, depending on the context. I saw the Seurat show recently at MoMA. Because it was a retrospective show, there were many of his early works. He could always draw magnificently. But there was a trajectory of his talents, starting with the early traditional work, and ending with works that were entirely original.

Intelligence needs to be developed. The brain succeeds by repetition. If you do the right thing over and over, the brain gets stronger. If you do the wrong thing over and over, the brain gets weaker. It's great to look at Seurat as an example because he displayed the depth of his skill and its development. Skill was no longer the issue.

P You spoke also about bringing "the reader" to a greater attentiveness.

M I thought one could make the comparison between a meditation and the experience of art, in a general sense rather than only in the visual arts. In the pursuit of meditation the fundamental objective is to clear the mind of all the stuff that occupies our waking life: our prejudices, our beliefs, our concerns, our anxieties.

Our minds are filled with experiences and beliefs. My assumption is that all of these are impediments to experiencing "reality." What prevents us from experiencing our own reality is, in fact, the intrusion of all this other stuff, which everybody inevitably carries in those primitive parts of the mind that we cannot control. When you meditate, or clear the mind, you can actually experience your own reality without all the noise that goes on. When I drew a portrait of my mother, when I was seventeen or eighteen years old, I realized, as I shifted my mind to attentiveness, that I had no idea of what she looked like, that her appearance had become fixed in my mind through the years, and as a result of that I could no longer see her. If I could not recognize my own mother, obviously I had not been paying attention.

P You saw her in an unreflective way, a sort of clichéd image from a personal point of view, with no examination...

M I could not see her as she existed at that moment, until I became attentive by deciding to draw her. What I held in my mind was an accumulation of all my historical encounters with her. My assumption is that we build up a reservoir of preconceived ideas about everything, which becomes the basis for our lives. And then, every once in a while, perhaps through meditation or through art, we see freshly and without the encumbrances of our own history. That's what my fascination with drawing is, for one thing, but also to make connections and comparisons between creating art and the experience of mediation. To me this doesn't seem fanciful at all.

P Art has a relationship, obviously, to the person who created it. But it is also known to the artist that his work will be seen, even consumed, in some way. Do all artists intend to provoke the recipient's mind to action or attentiveness?

M The fact is that we develop immunity to experience, because we have to, because if we responded to everything in life, we could not tolerate it. Most of our lives we spend deflecting most of the information we receive. You go out in the street and you are besieged just by what your sight, your hearing, your mind encounter. People stop paying attention; they revert to cruise control. Every once in a while something will happen, like somebody dies, or you have an accident, or you see a great painting, and you realize that you are living in a semiconscious state. In fact, that may be the only way humans can cope with the complexity of life.

What paintings do, and what theater does, and what poetry does, is to penetrate people's immunity and to embrace the puzzles to be solved. That's what I mean by the phrase "moving the mind."

P You said earlier, and you were certainly right, that any piece of art is received differently by different people. But then the artist, either consciously or unconsciously, had some point in the horizon that he was driving his art towards and, presumably, was trying to drive his viewer towards. For example, *Guernica* is by common agreement a great piece of art. It has a political subtext that is unmistakable. It is at once a great piece of art and it is at once a message painting. When he painted *The Absinthe Drinker* somewhat earlier there presumably was less of a desire to have a message than to render some perception of what he was painting on canvas. But in both cases he knew other people would see the work. So if art provokes the mind to action or attentiveness, does the artist—do you—just want to have the viewer see things afresh?

M Yes, but perhaps I haven't been clear enough in explaining this distinction. The narrative content of a work of art is, from my point of view, important, but it is the least important thing in terms of what I'm talking about. Narration as such does not transform people in the same way. It may make then aware of an event that took place. But when somebody looks at *Guernica*, the message that they get is beyond the specific occasion and the specific place in the painting.

P It transcends the incident and may just be telling us also about war.

M Why are we unmoved by many of the skills of academic painting? Because their information is complete and unambiguous, so you have nothing to add. As a result, the mind is not moved. The whole issue about abstraction in pictorial terms is the ambiguity of information. The philosophy of modernism suggests that the viewer completes the work. In bad academic painting, you basically look at the picture and follow the story. It's what you learn about the nature of good and evil or dark and light.

P Did you choose the pieces in this book because you like them, or because they exemplified something? You arranged these pieces specifically to tell us something; presumably you want us to share some experience. I'm thinking now of two pieces of art, and I wonder how what you've done stands in any relationship to them? I think roughly at the time of what was called the French "new novel," a writer named Michel Butor created a work which, if I remember the title correctly, was *Roterweir, Free into the Wood*. It was composed of fragments of prose by a very skilled writer, which were all jumbled, and the reader was asked to assemble them himself. Now, I don't know enough about Butor to know what his purpose was. Perhaps he wanted the experience that the reader had, regardless of how the reader might assemble the fragments, to

be the work of art or the transformative experience? I don't know if he ever commented on it or not. But he had a purpose. This is a very deliberate piece of work that he did.

M How could anyone ever tell what the artist's intention is? It's irrelevant here, although, I must say, everybody seems to care about it. Under the general heading of intention regarding authenticity, the viewer asks, "Am I being made a fool of?"

Incidentally, there's a good reason for that question, because a lot of people are trying to fool you. Historically, art has frequently served as a tool of persuasion.

P People do ask that question. Yes, I would say the great majority of people ask that question.

M They ask it all the time. In our culture, with art being seen fundamentally as a precious object, its material value cannot be separated from its spiritual value. But finally, the issue is not about the artist's intention because the artist can intend to produce art and fail.

I am not so presumptuous to assume that my drawings are art. I have no idea whether they are or not. I thought it would be awkward for me to do a book organized around the principle that these were artworks. So I struggled with a way of putting these drawings together that would be an artistic experience even if the drawings themselves were not.

P So is there no relationship between what you experienced choosing and arranging the images and any specific response the reader might have?

M That's correct, because there couldn't be. First, I chose the drawings—basically, they are the drawings that I like. So they represent my personal preferences. Then I put them together where I saw certain connections and threads that might not be obvious in all cases.

P That they might see something else in them and in the works as a whole... So if I take this a step further, the arrangement and the sequence and how we perceive them is really what the book is about, unrelated to each piece as perceived by itself.

M I'm hoping that people will look at the individual pieces. But I think there is also a kinetic experience of moving through the pages and seeing the effect of each drawing in light of what precedes and follows it. As I said earlier, it's like a musical line. Then there are, you know, interruptions: of single pages, of individual drawings. It was like making a film, cutting to another scene in the middle of the lovemaking, you know, the dripping faucet, and then going back to the lovers and so on. Will you think, finally, that what you have is an ongoing, pleasurable, melodic line?

P This work is more about the process that you go through and how you perceive where you fit into the activity, and maybe even of all art and anything that has a context outside of the work itself.

M In most of my work there is an objective to communicate a certain kind of information. A lot of my work is based on narrative and storytelling, and a lot of the illustrations that appear in this book *Drawing is Thinking* were done specifically to convey information of a "literary" kind. Here I've changed the context to achieve something else. It's literally taken me a lifetime to begin to understand what people mean when they talk about art. And I think I finally have a standard by which I can think about it. The art that we experience moves us, in the deepest and most unconscious way, towards the perception of our own reality. And when we perceive our own reality we feel liberated and expansive. Someone said that the mutability of the mind, the mind's ability to change, is the most profound indication of human freedom.

P You've spoken often about the connectedness of all things. I was reminded of *War and Peace*, where Kutuzov also talks about this. To paraphrase, say that a man in Mongolia puts down his cup of tea on the saucer, and there's a small clink. This small clink connects up with some woman shopping in a supermarket in Copenhagen. There is some movement of the cup and saucer, it exerts a downward pressure on the table cloth, there is some sound from the clinking that travels in some way, and that in some way everything happens in a relationship to something else. Everything that happens is part of cause and effect.

M There are no individual events; there is nothing that exists outside of its context, everything relates everything else in the universe.

P Would you like to comment on any of the themes that underlay your selection of material? Not necessarily any that you began with, but some that emerged from the doing?

M Well, that would be hard to do, though I suppose I could do it quite easily if I was looking at it directly. But sometimes it's just a kind of shadow, sometimes it's a shade of blue, sometimes it's a rim of a hat, sometimes it's a nervous line. I mean, what is not easy to decipher is what the criteria of selection was, because it shifts from one drawing to the next. To be truthful, I don't know why I finally put those drawings in their current sequence, except that every once in a while I would say, "Yes, these feel like they should go together."

A lot of this book relates to neurology and the way the brain works, but it also has to do with a

search for the spiritual that goes beyond our ordinary experience.

P Would you say that there are examples of portraiture that you consider more juxtaposed than others? I'm trying to see if there is any flow to the way you approached the project.

M That approach is more academic than I want to be in the book. The only meaningful work that anyone ever does is work that is done while you don't know exactly what you're doing. This also applies to trying to describe a painting. Everything in art that is profound and fundamentally important cannot be described. You can describe many things, but the core reality of experiencing art? That cannot be described. So I can talk about, for instance, a picture of a pope opposite Nina Simone, the two of which have certain things in common. Certainly, there's a kind of brown color that's used in both, the all-over shape of the head and form of both the pope and Nina Simone are very similarly attenuated. There is also a very big difference in representation. Nina Simone is quite linear and tentative and the pope is very fully realized. But, it's very important to understand that they are both different manifestations of abstraction. There is no reality to either drawing, and so to see that the representation can exist on many planes and still be abstract is one of the points that I'm hoping to make. But then there are maybe another two dozen things that somebody else would say they saw as a kind of understanding as to why the two drawings are where they are.

P The book, as you have designed it, has no identifiable parts. Really, it is a whole, and like all art, it is an experiment that works for the artist in the sense that he gives it to a publisher to publish, a client to make use of, or a gallery to sell. It has no meaning that one can define or make use of, but it, as what you say about art as a whole, is accessible only if it does in fact bring the reader, or viewer, to a higher attentiveness, one he otherwise would not have had. That is what I have come to feel about the book, and I think it's really quite unique in a book to have the artist-author consciously do that. Maybe you would like to comment on that or perhaps completely disagree with me.

M We were trying to produce a work that would be understandable on one level or another. It is a commercial work, one to be sold; it does have text, it has an introduction, it has this conversation, and it has details of the drawings at the end of the book. These are all fundamentally acknowledgments of the expectation and the state of the mind of the viewer and the reader. What we are concerned about is that very often if you do not prepare the reader for an experience they will basically resist it.

P As sometimes people feel alienated without some kind of a roadmap.

M Right. But when the reader goes to the back of the book, to a description of the work itself, I don't think—correct me, please—I don't think *that* gives him any experience. It just gives him some information. The only experience is from the whole.

P Well, I guess my point is that if we were really adventurous in publishing this book and wanted to say it is a work of art—take it or leave it—we would've published the book without any text at all, of any kind, no preface or introduction or front matter.

M That's true.

P And we would put it into those bookstores that would have it, and people would say 'What the hell is this?' And fundamentally the book would fail, at least in terms of covering its costs.

M Or on the other hand, it might achieve fame as a curiosity.

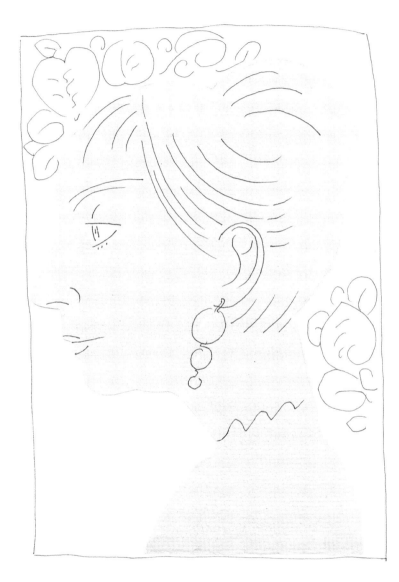

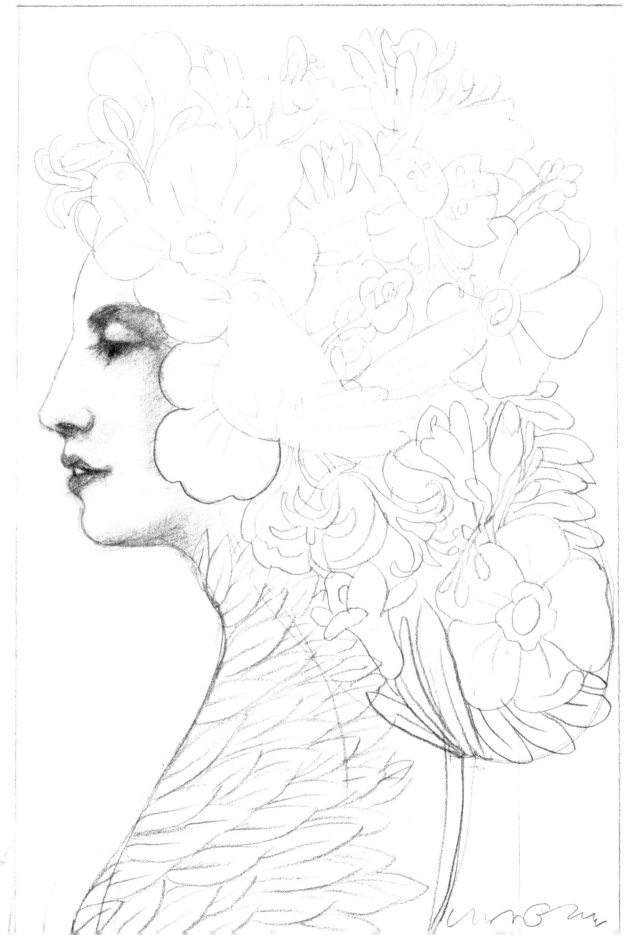

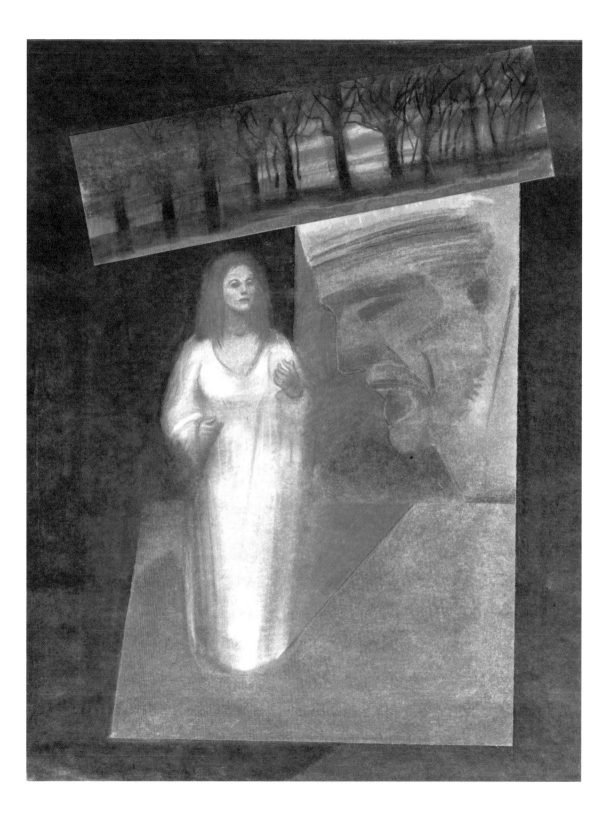

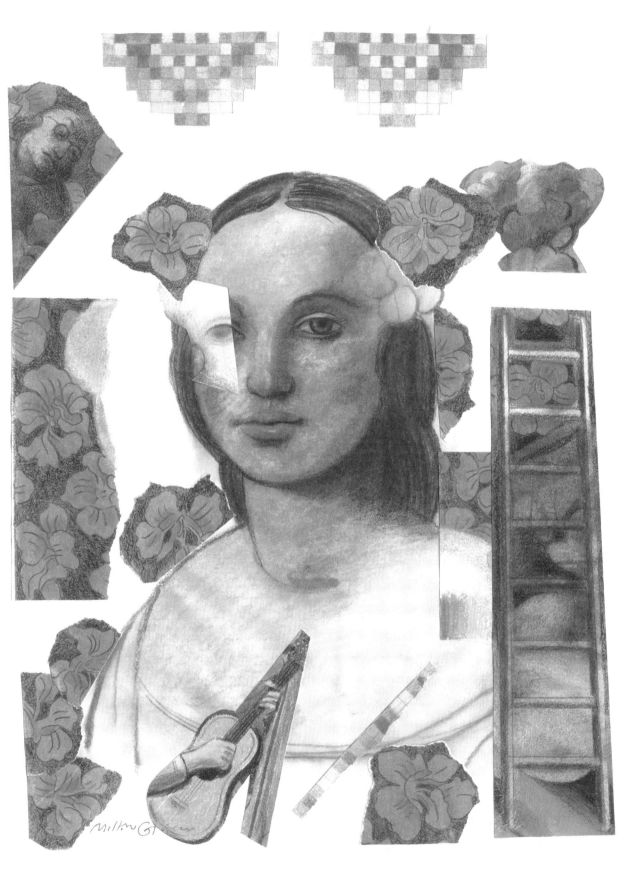

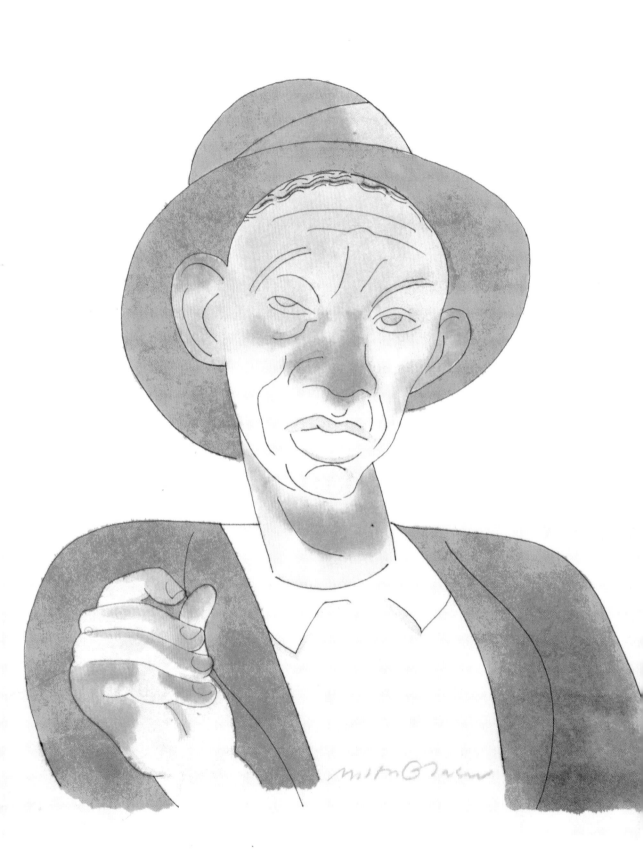

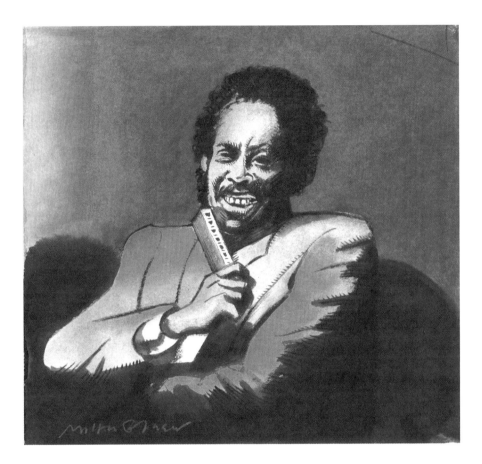

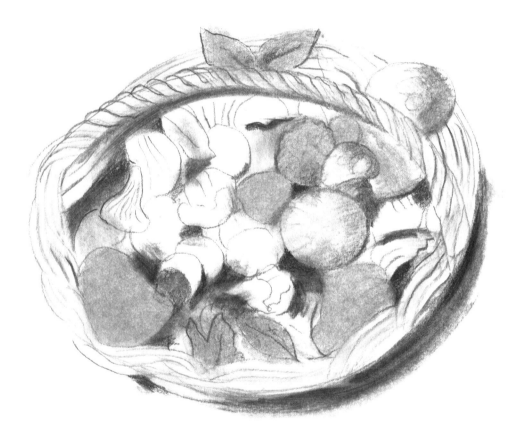

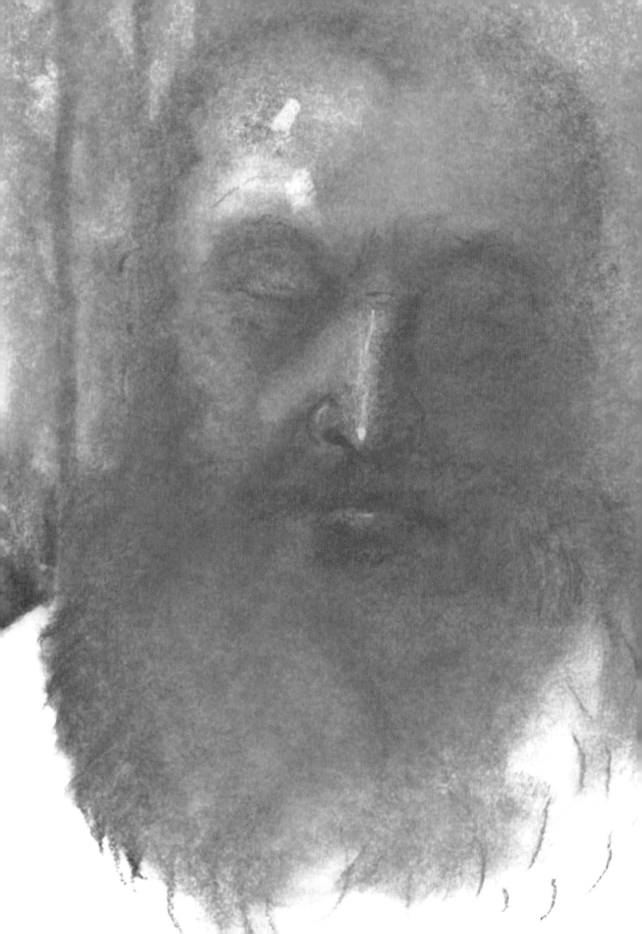

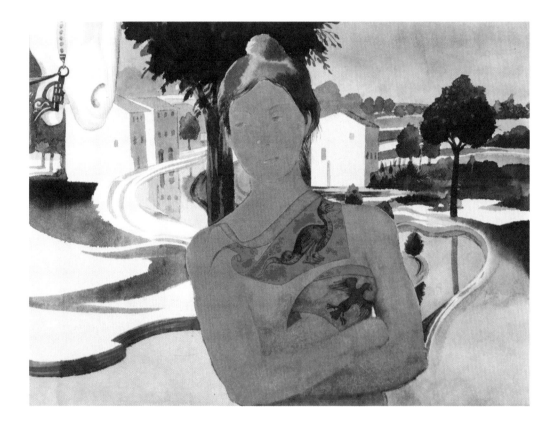

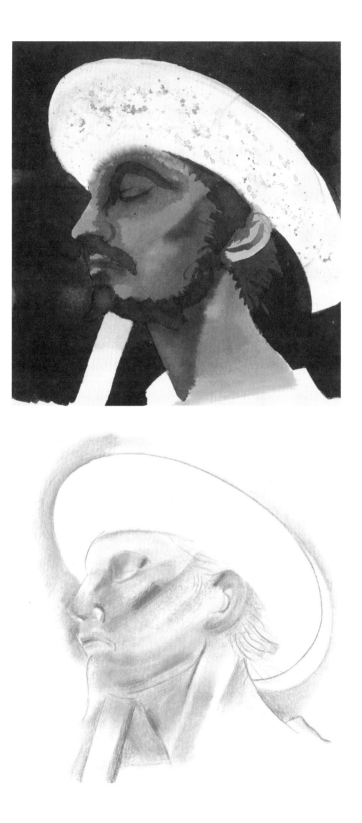

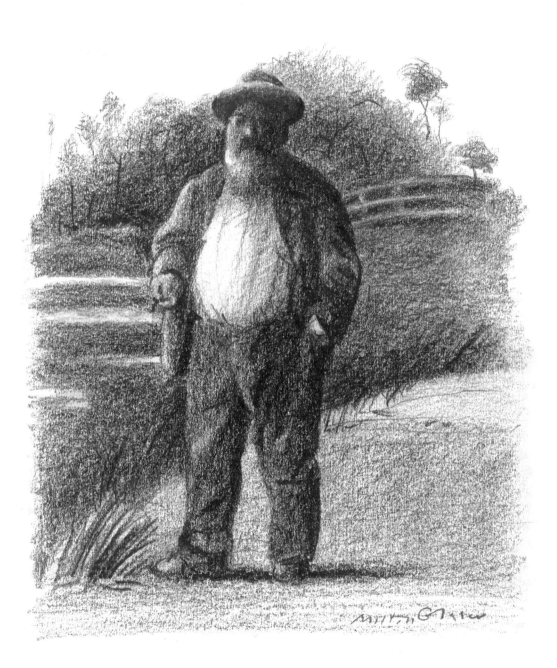

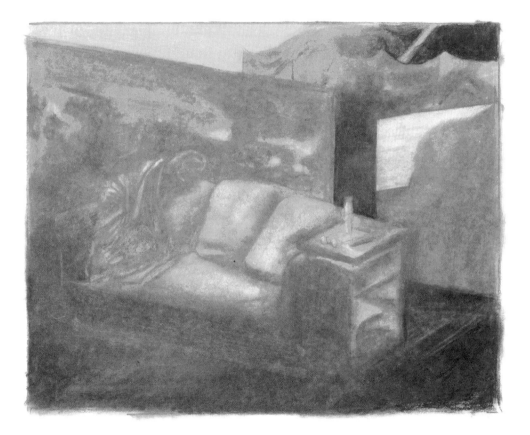

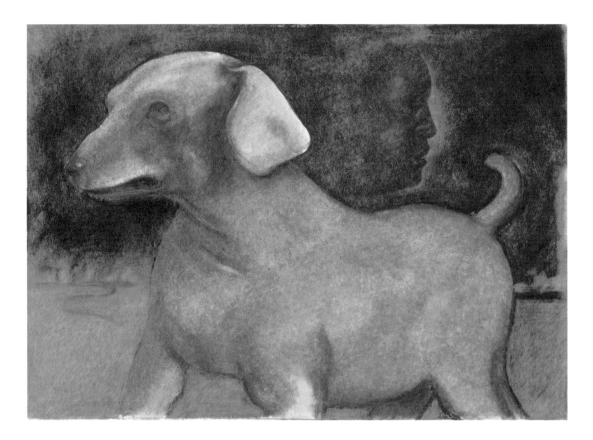

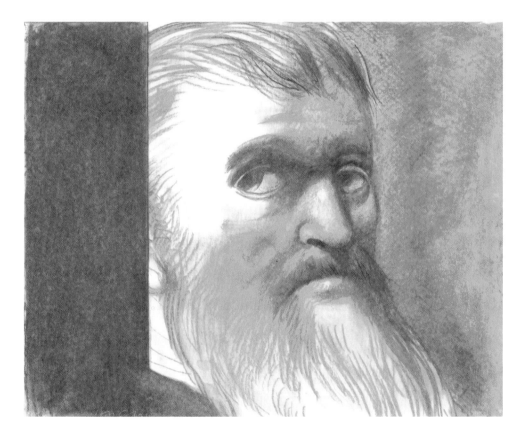

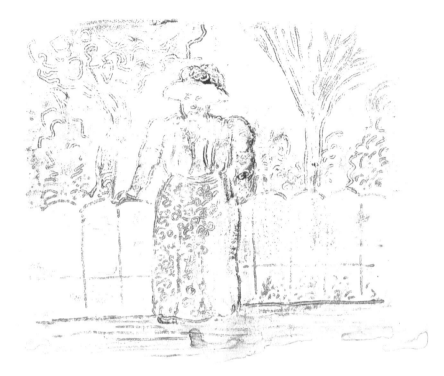

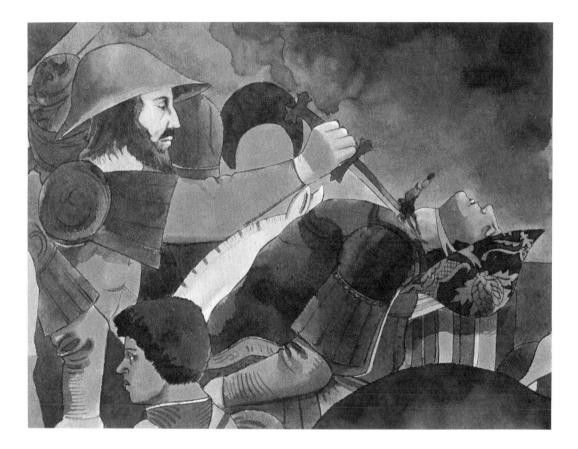

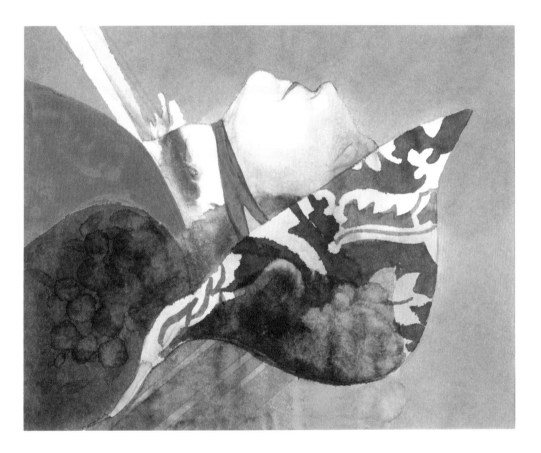

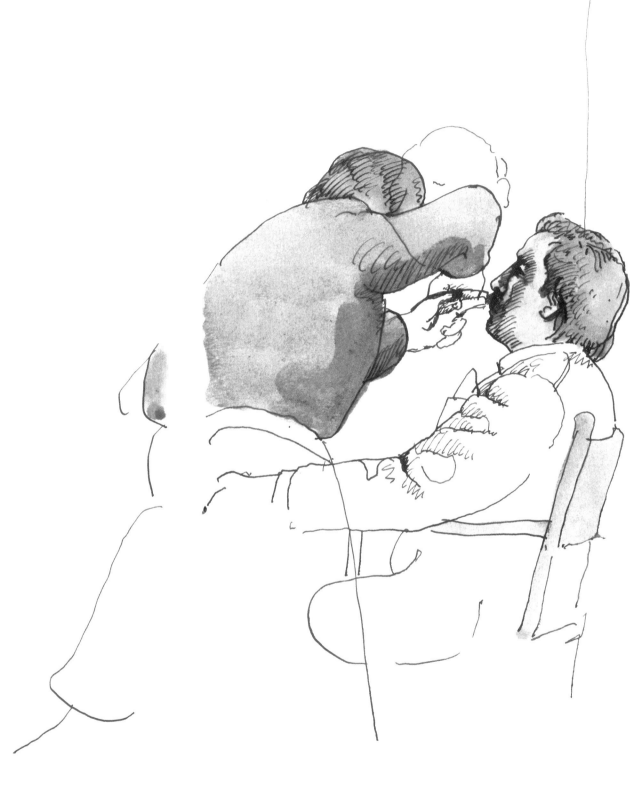

Stands set up to simulate 1800 style

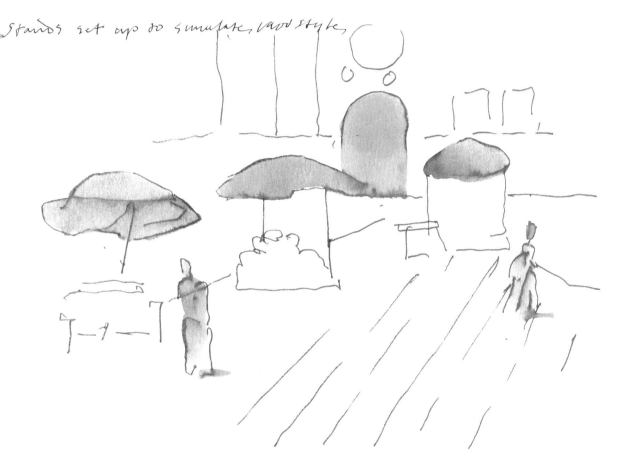

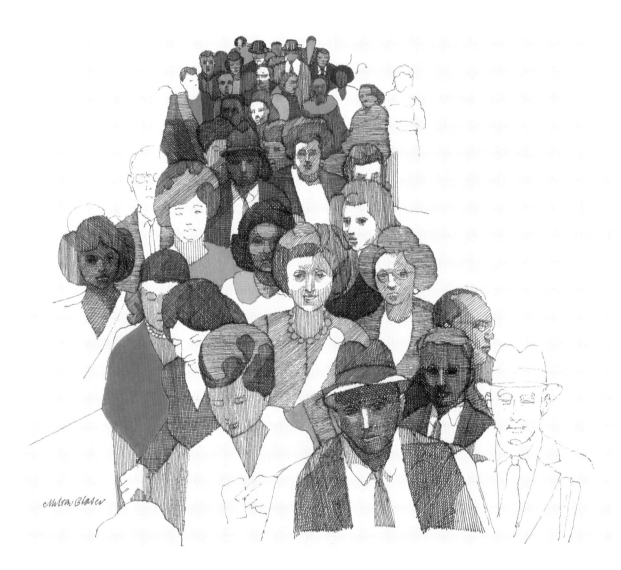

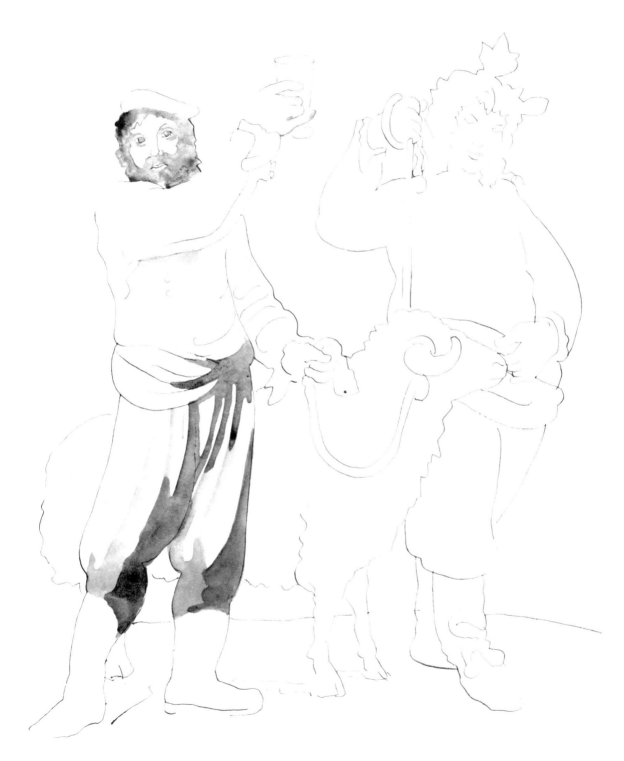

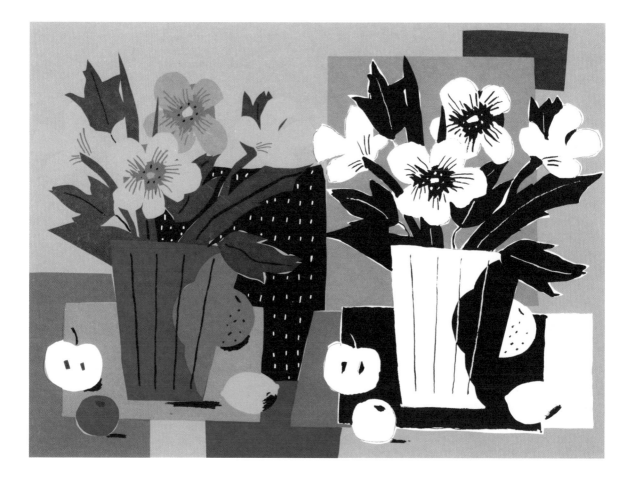

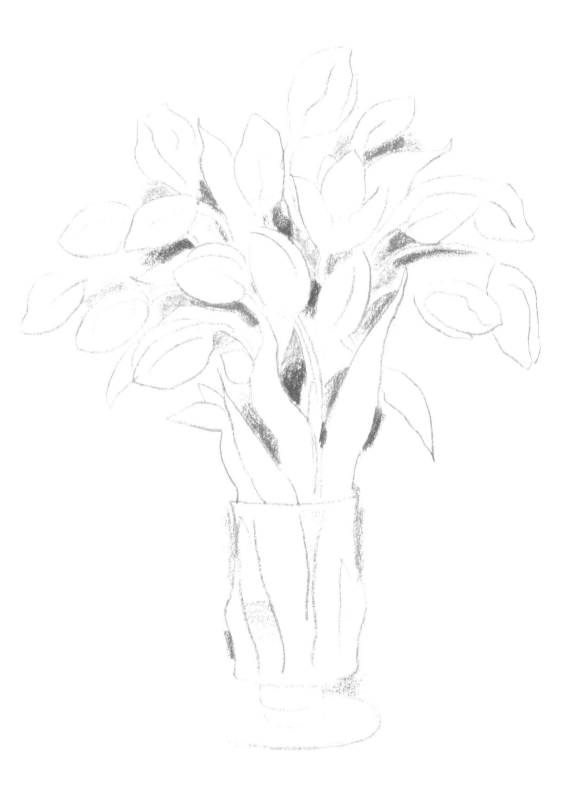

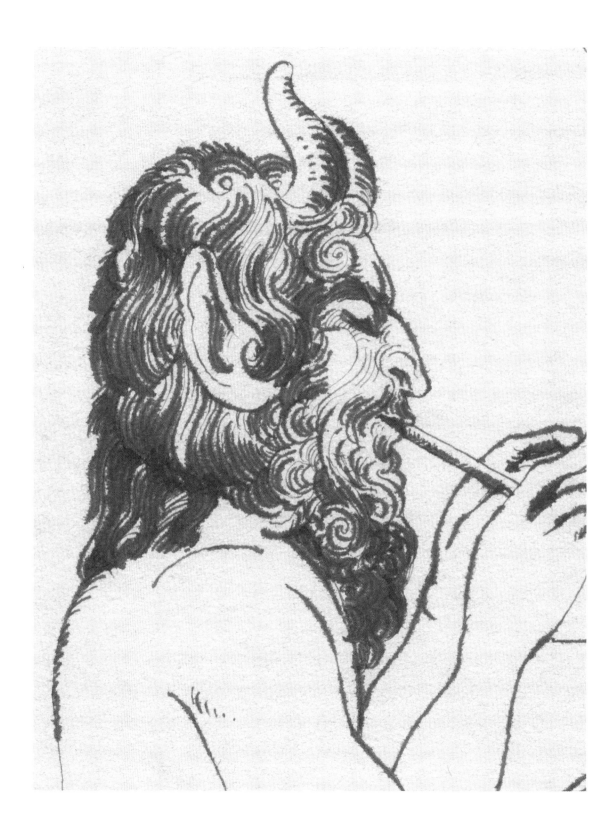

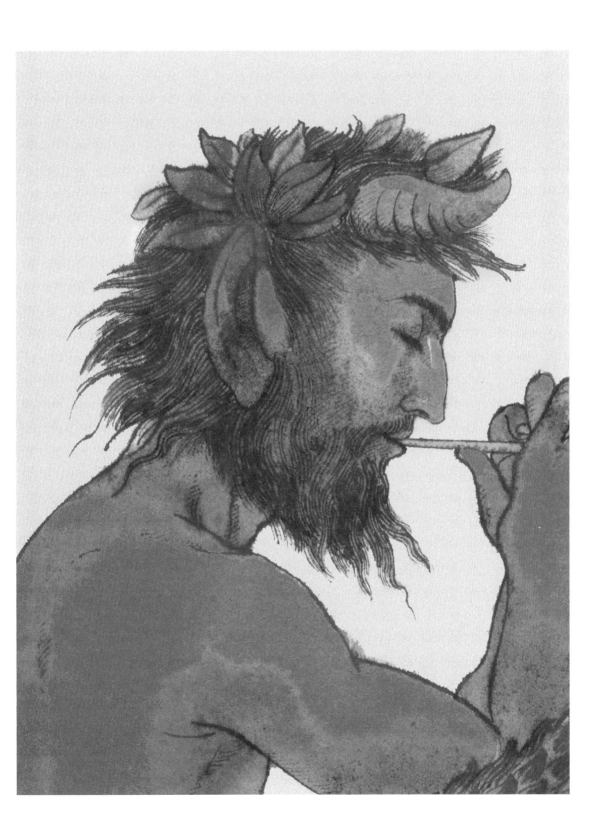

49

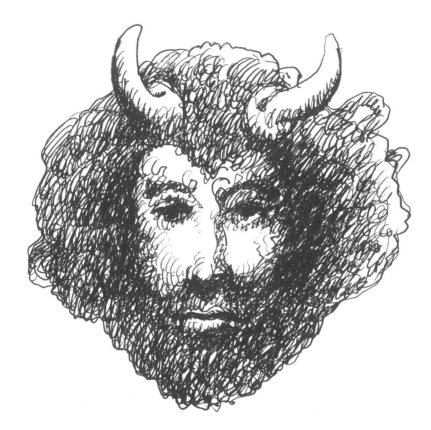

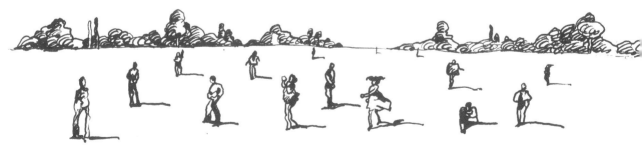

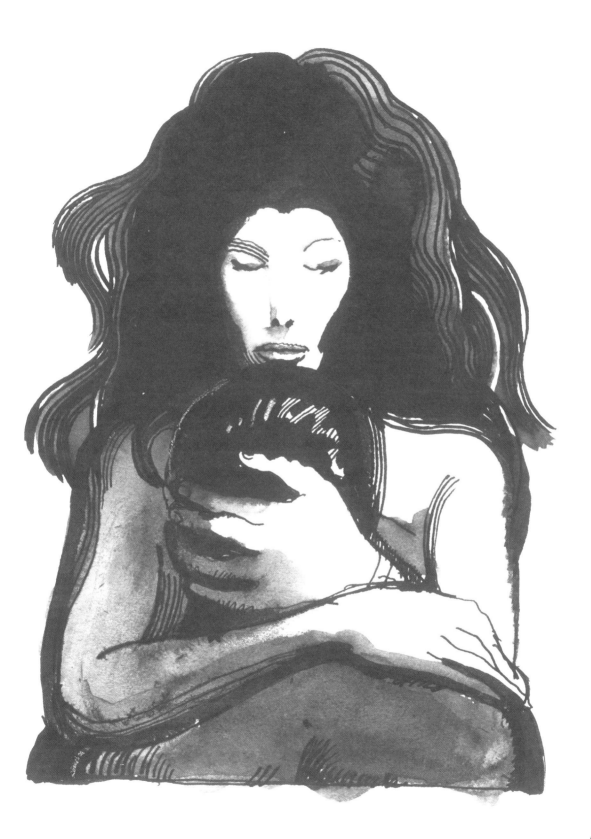

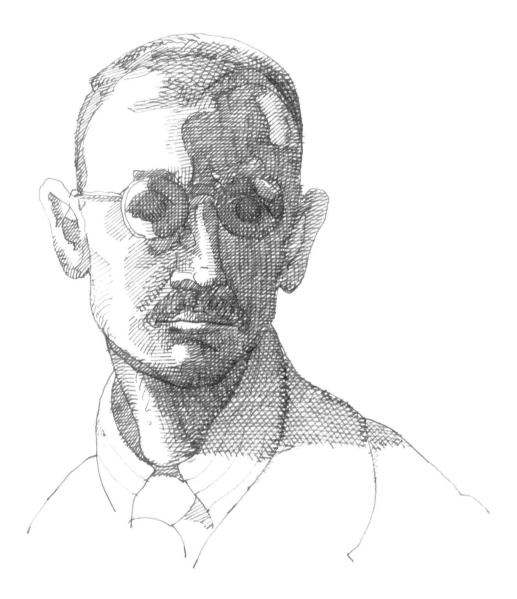

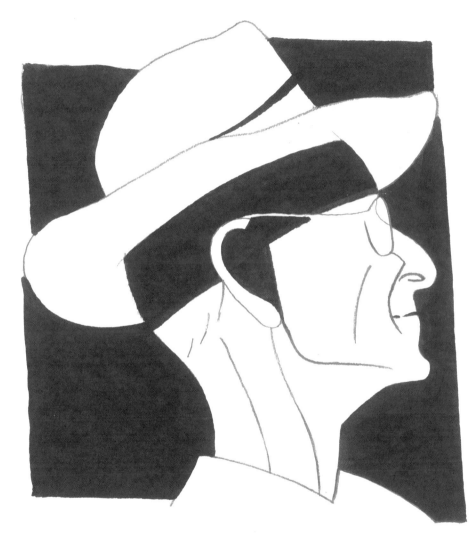

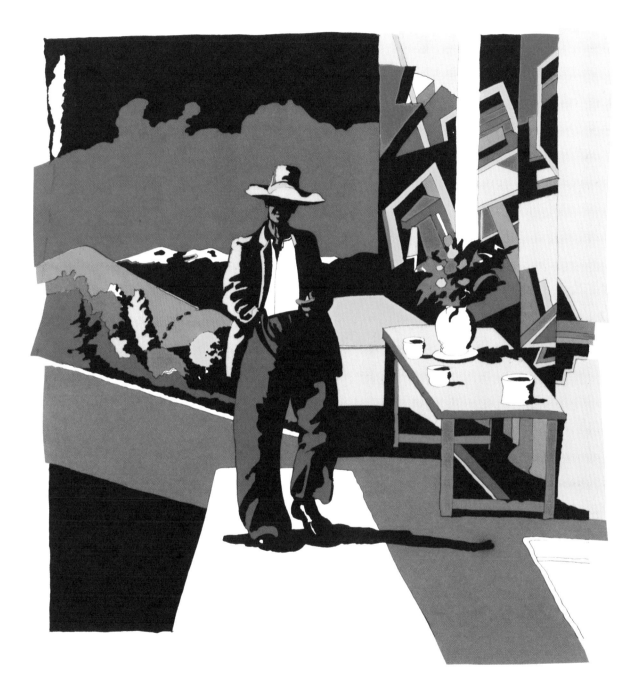

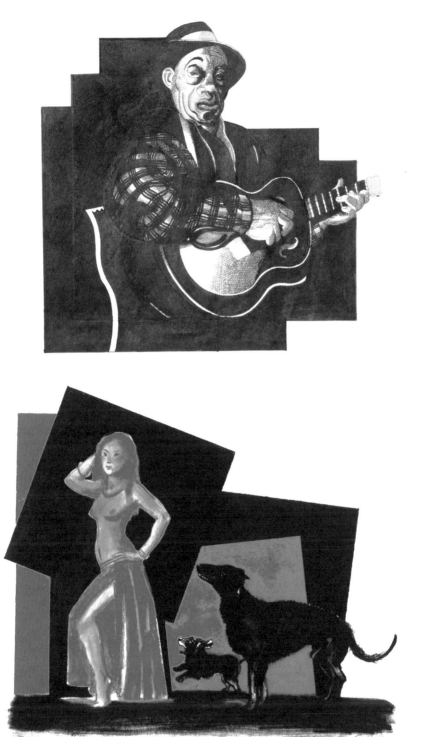

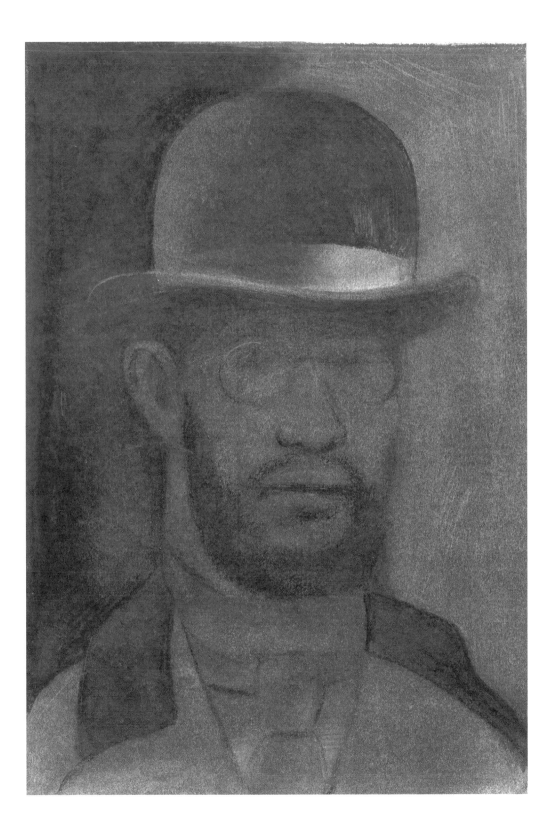

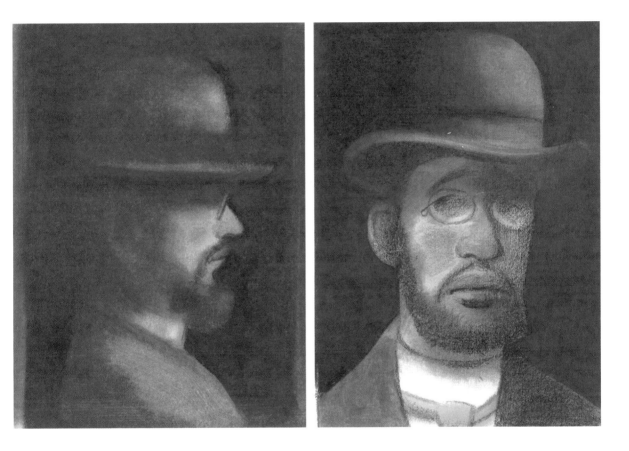

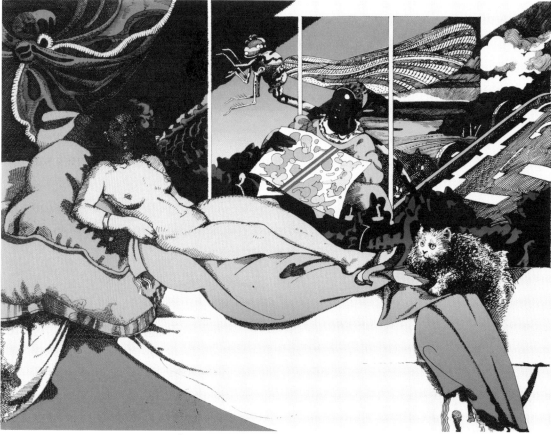

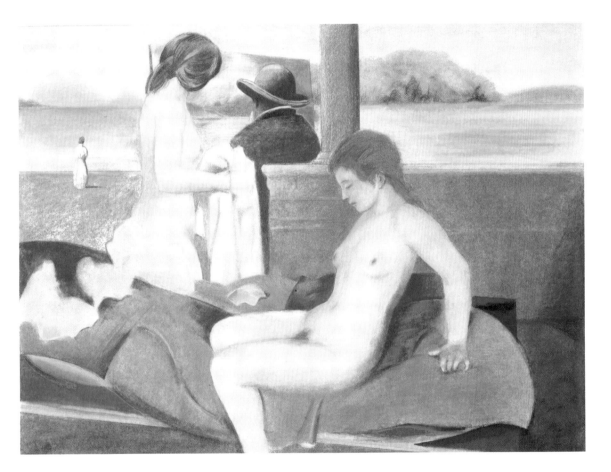

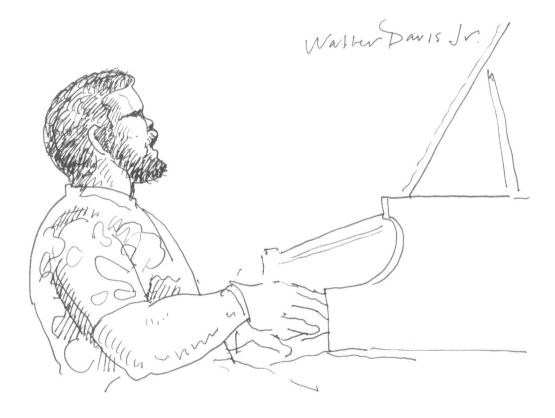

Walter Davis Jr.

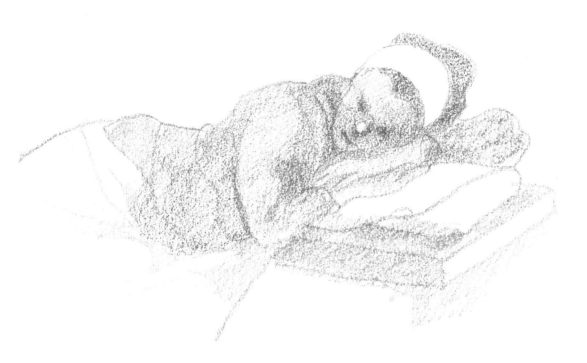

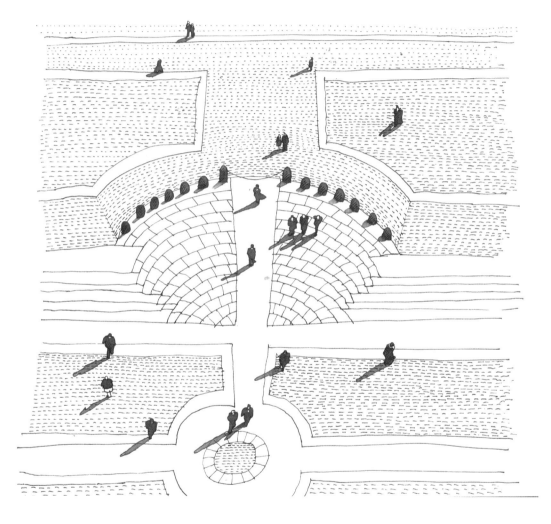

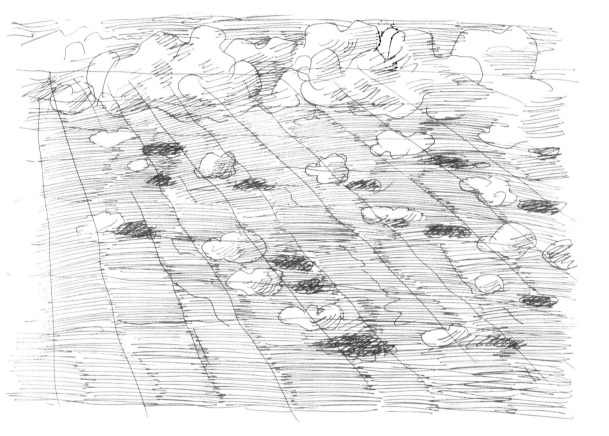

Aug 15, 1990 Clouds and shadows

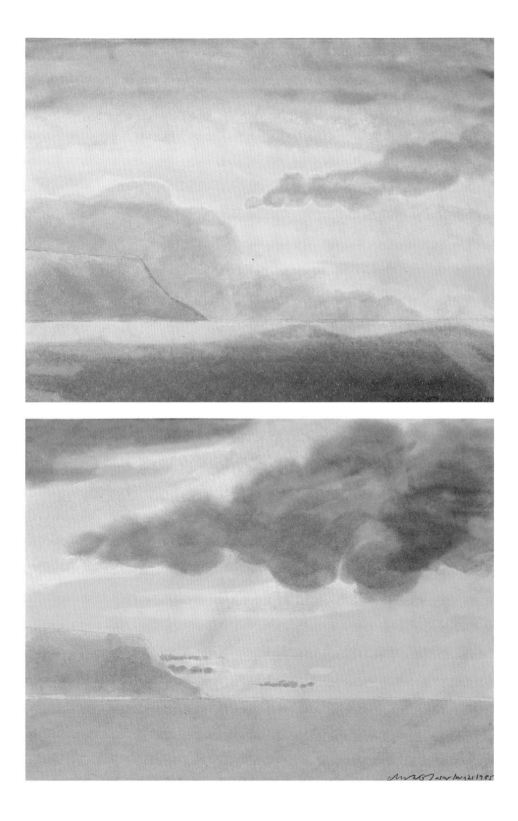

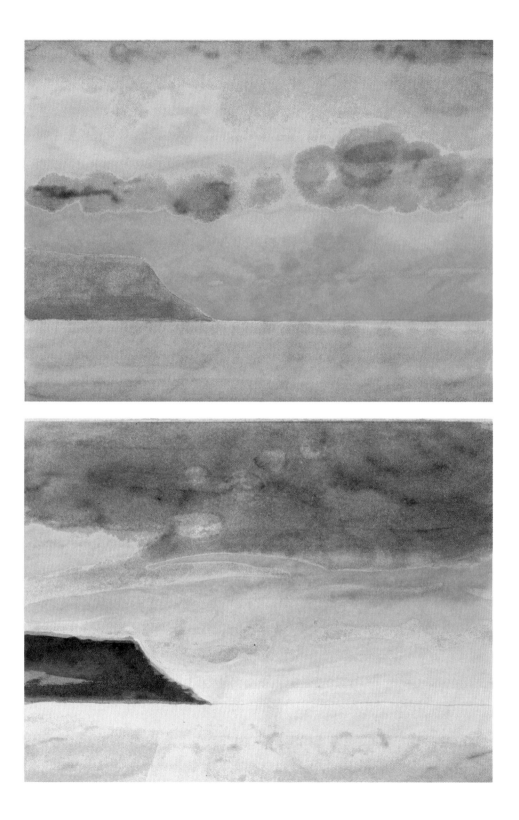

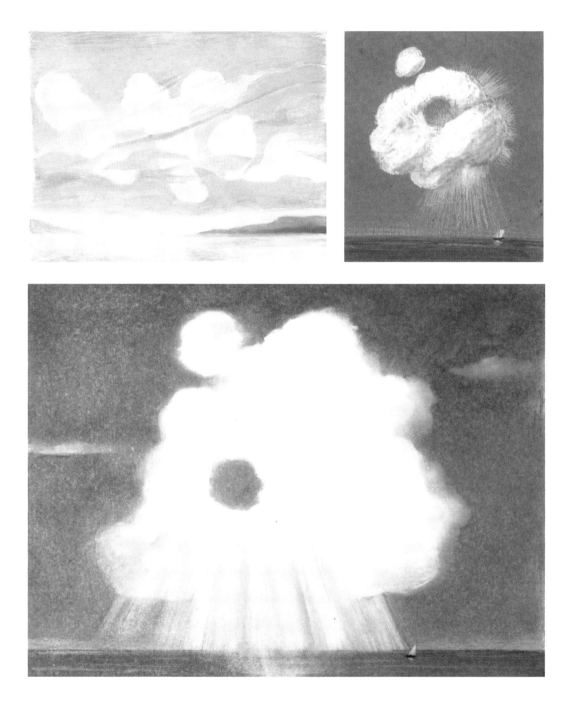

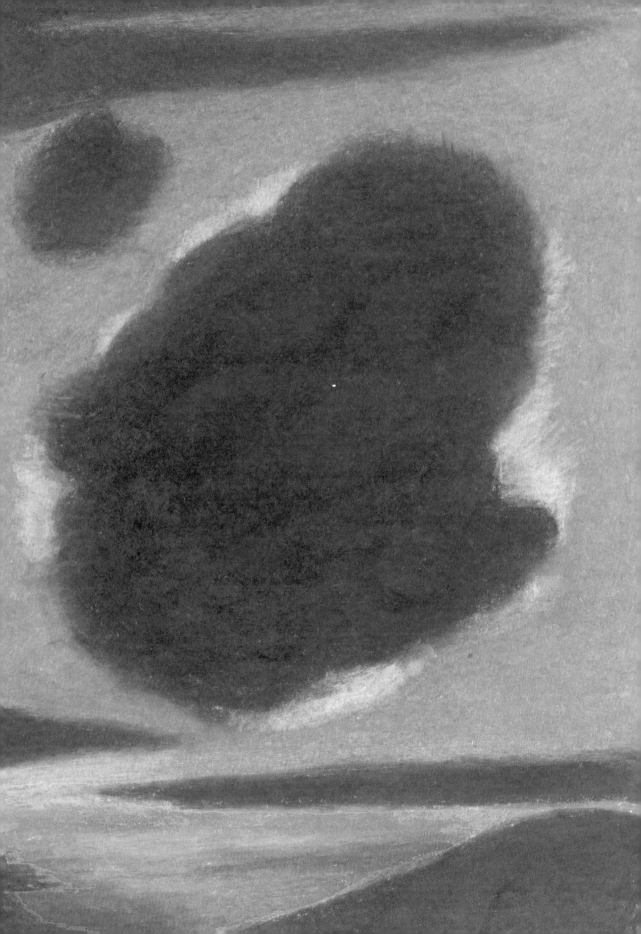

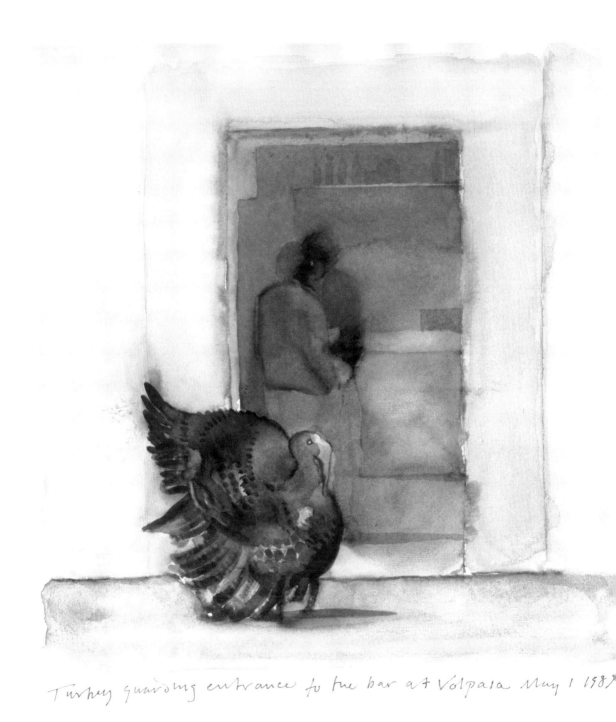

Turkey guarding entrance to the bar at Volpaia May 1 1987

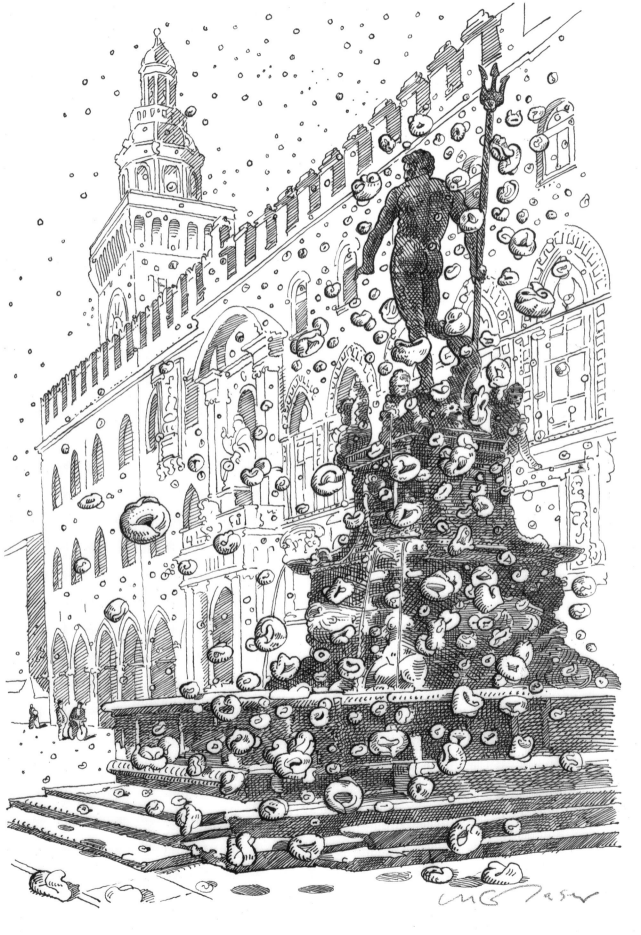

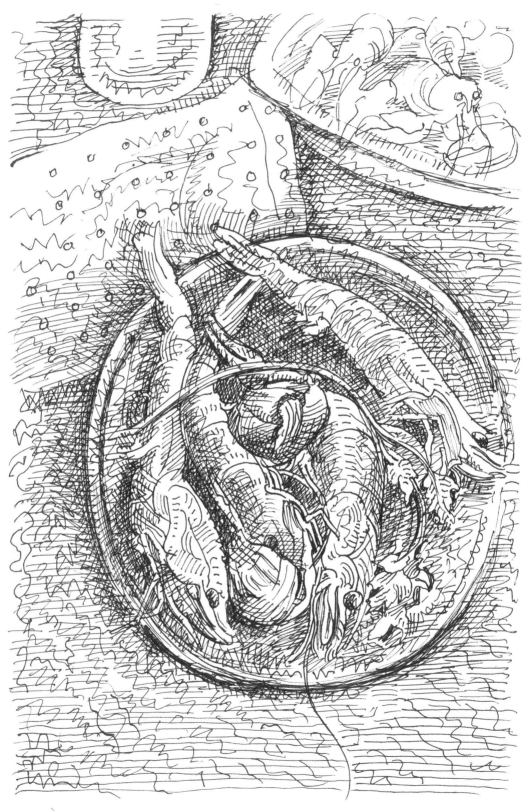

Fridays

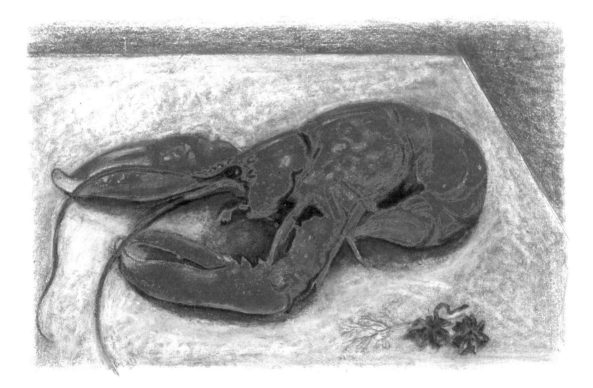

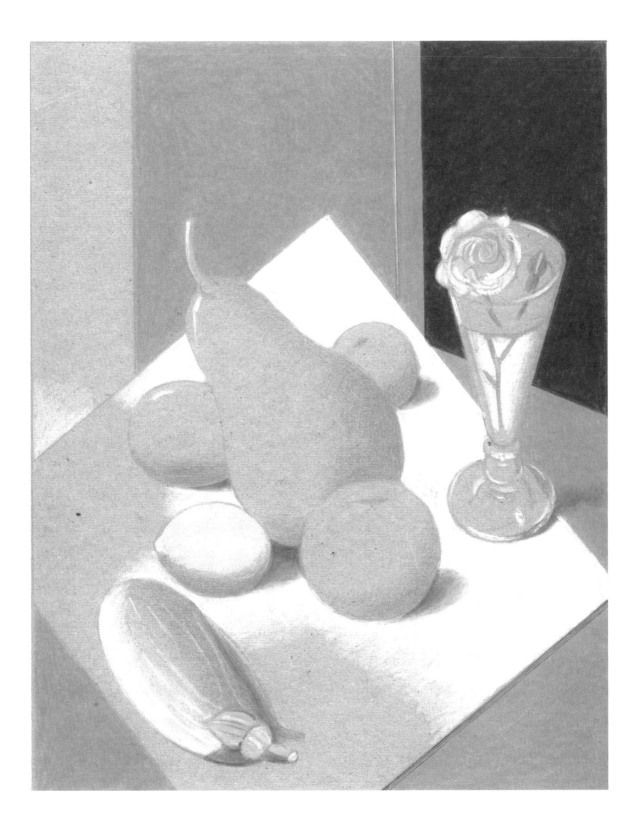

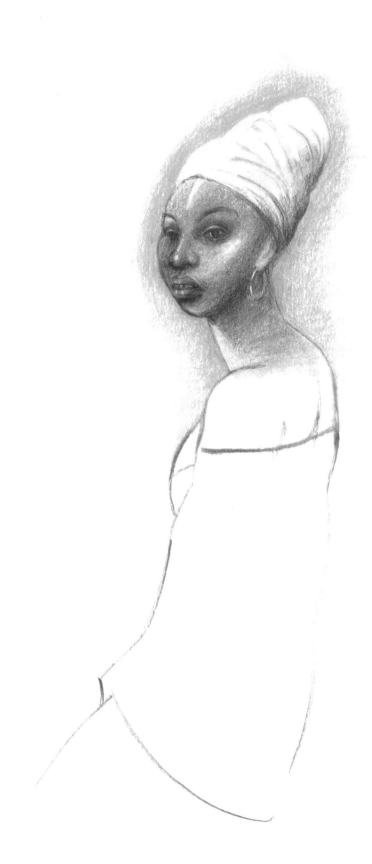

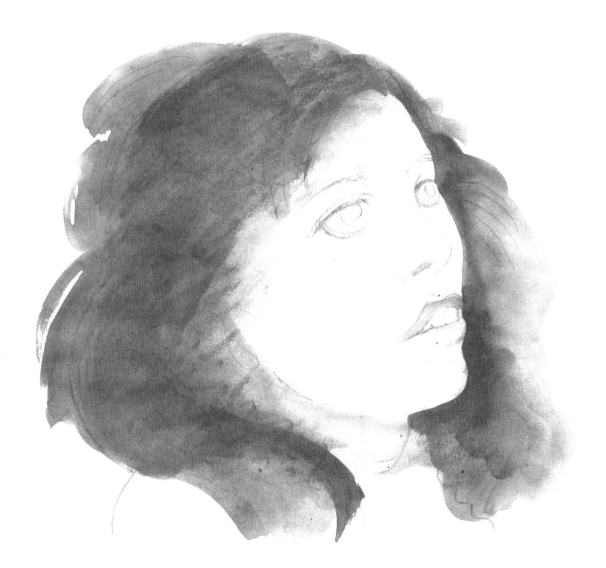

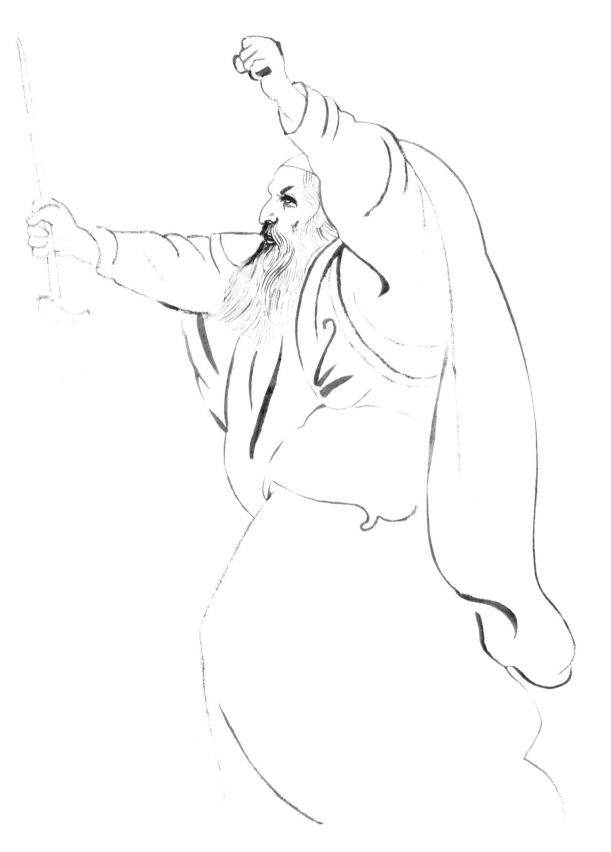

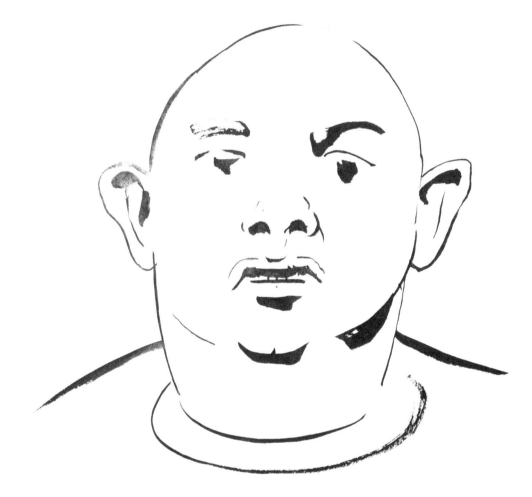

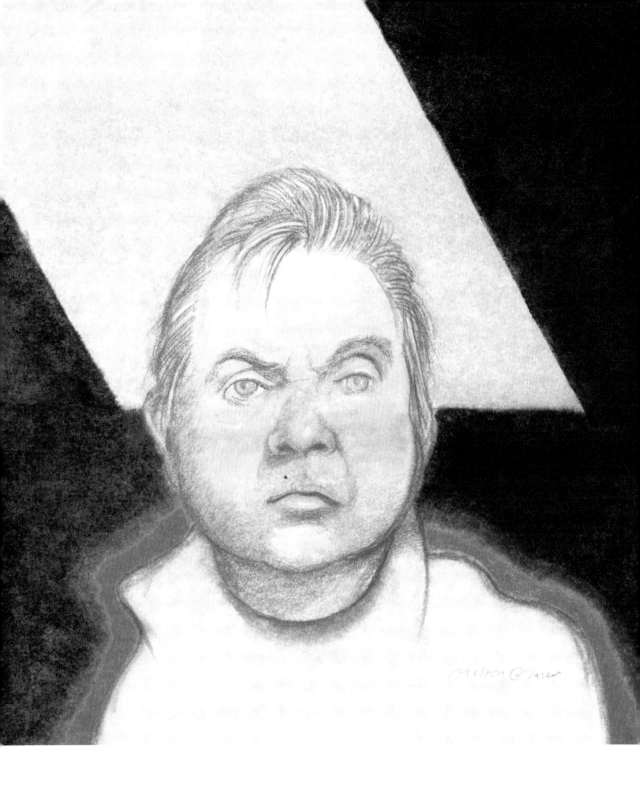

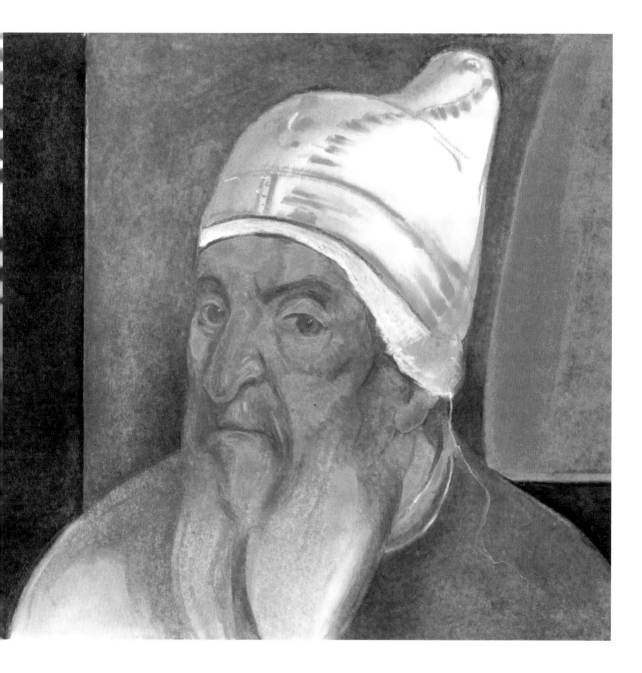

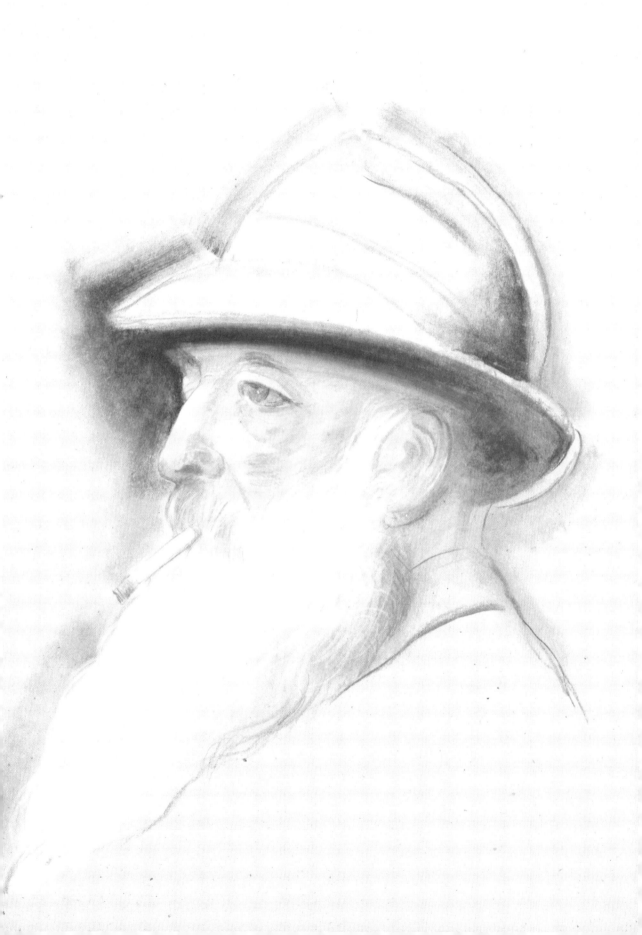

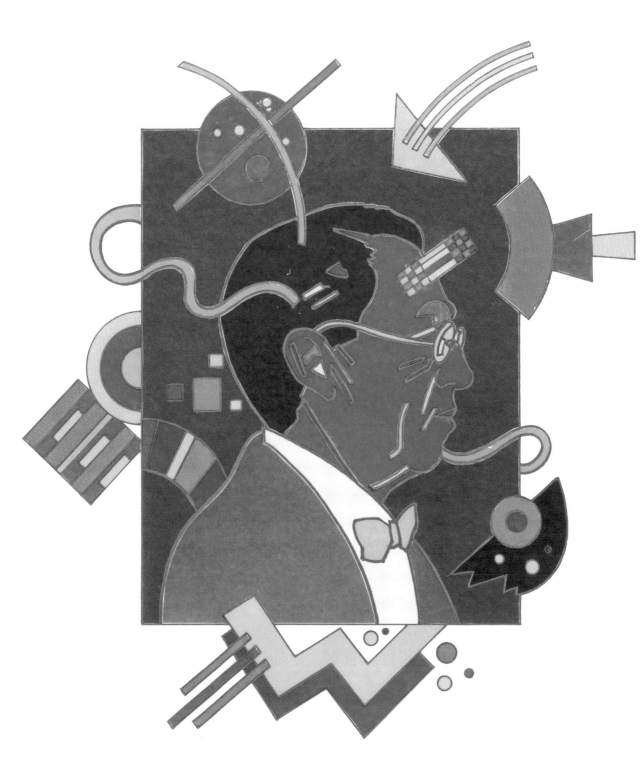

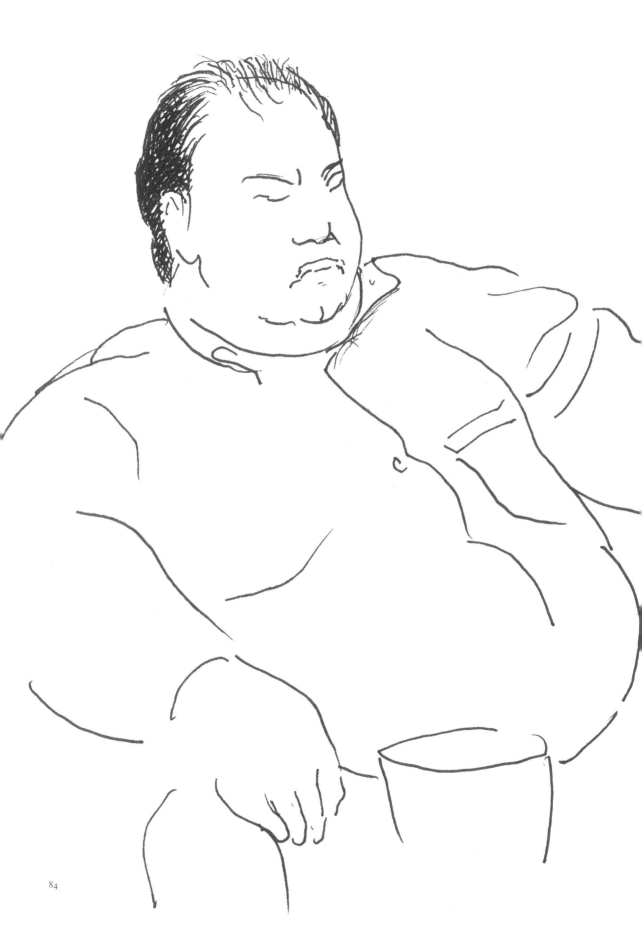

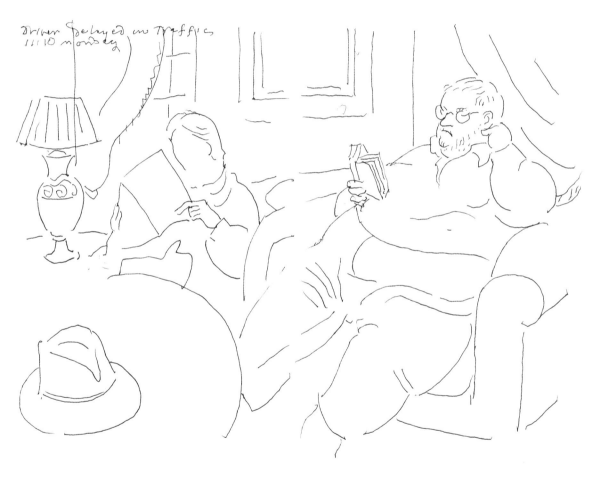

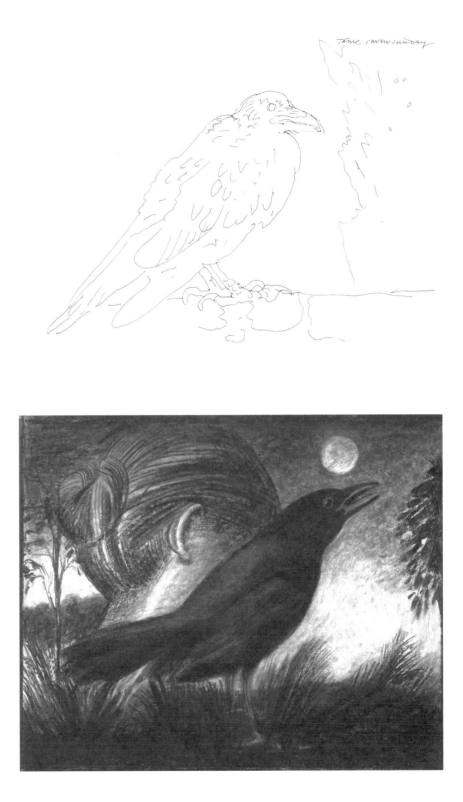

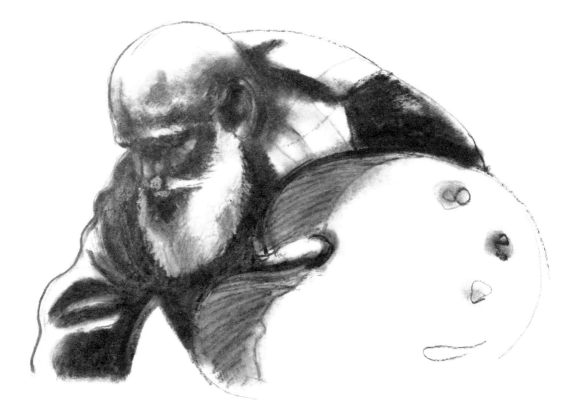

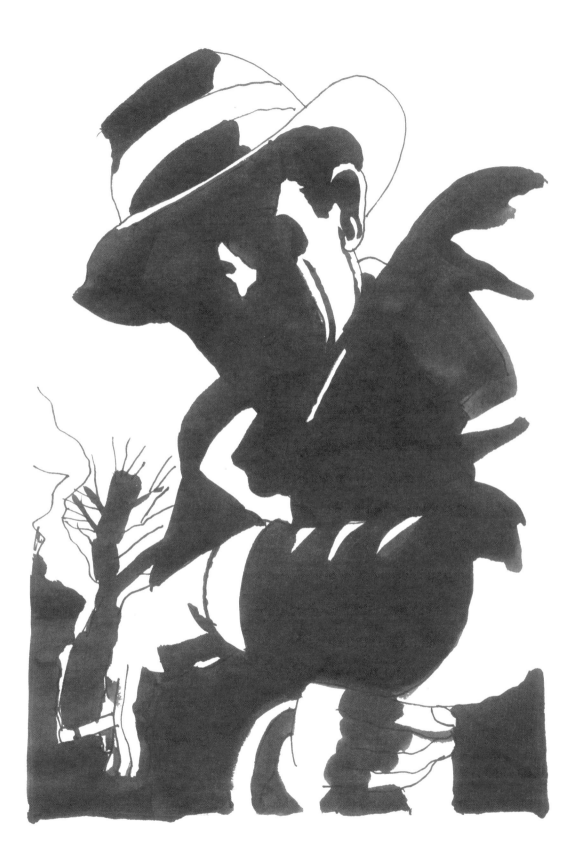

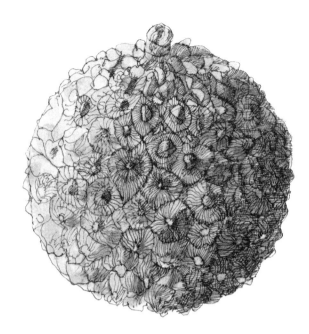

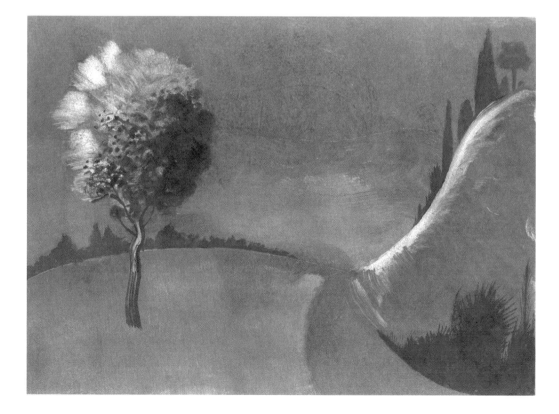

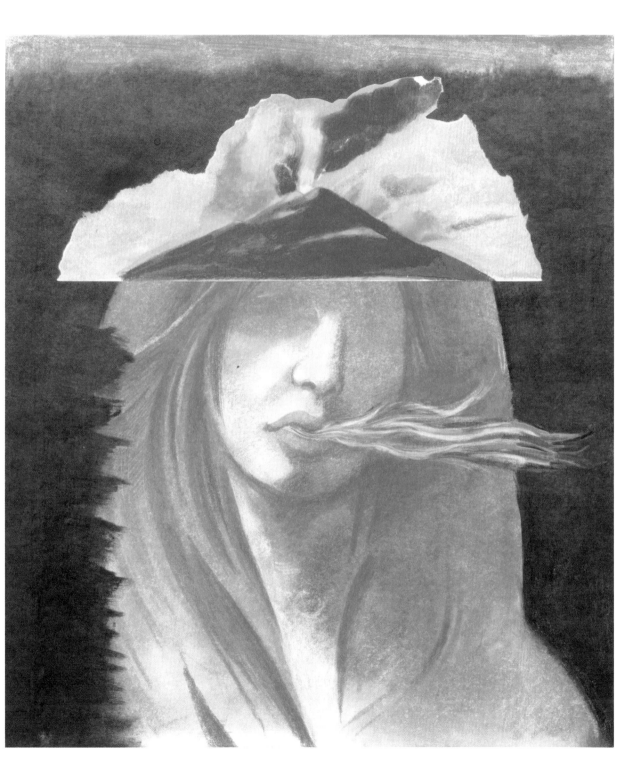

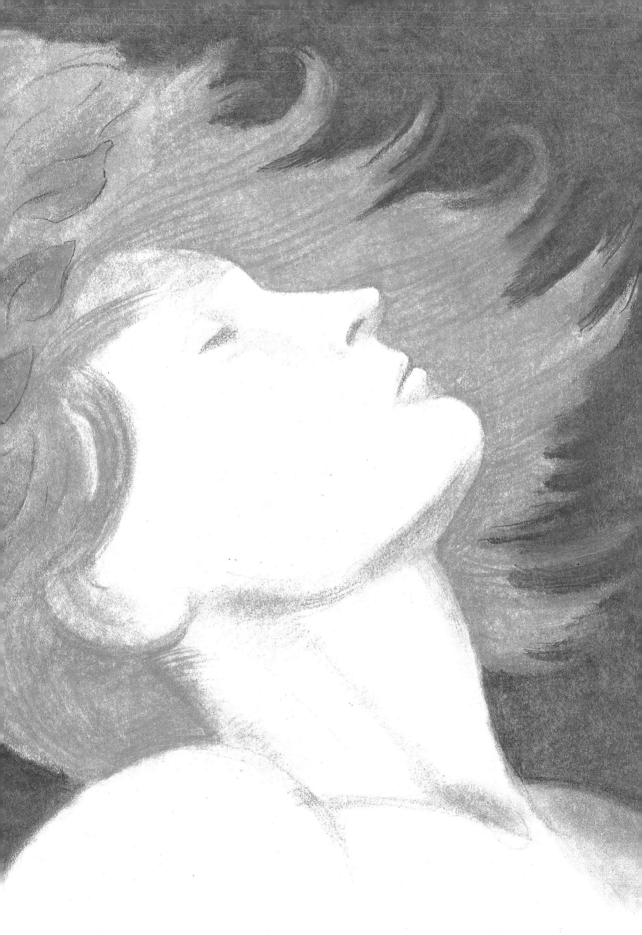

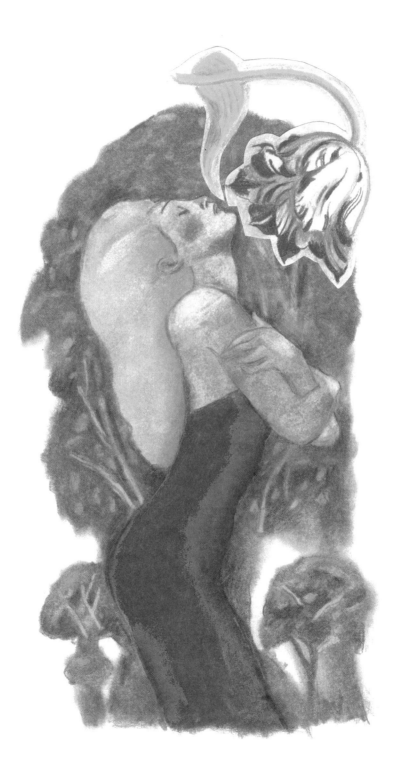

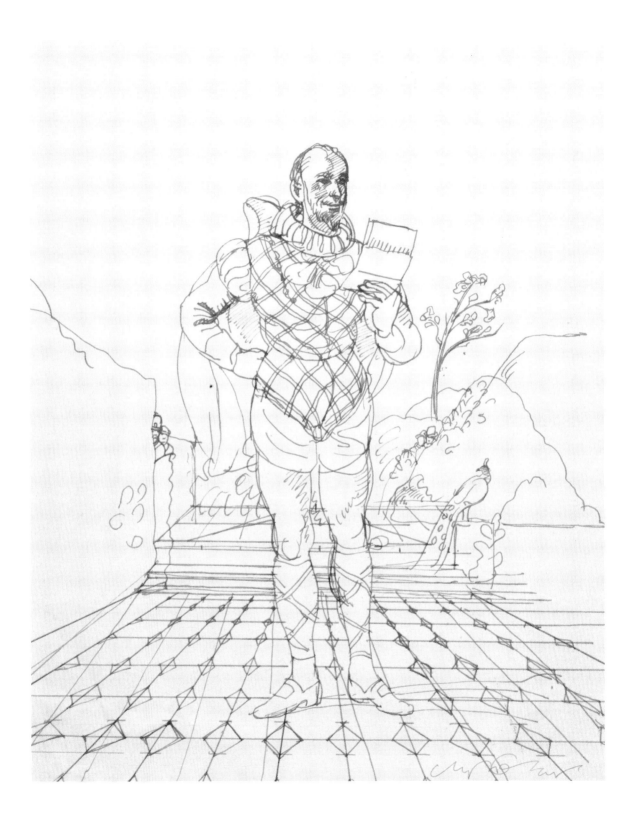

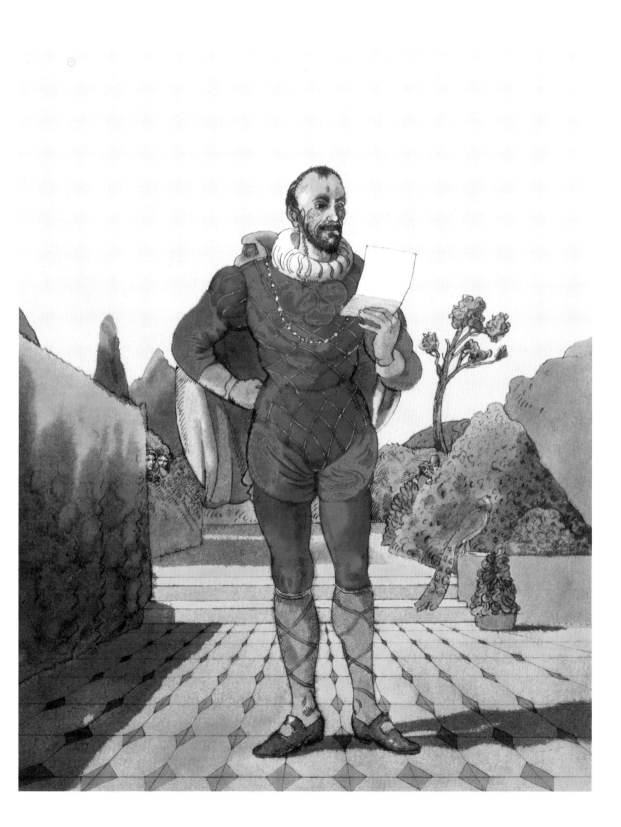

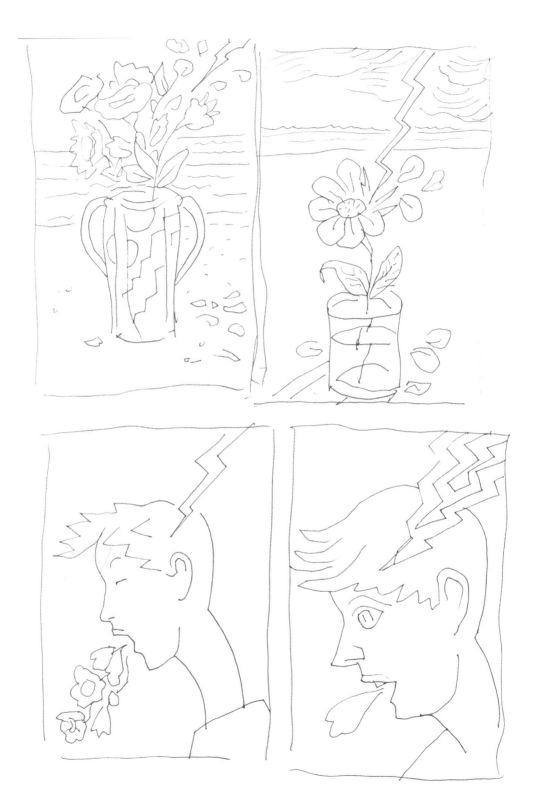

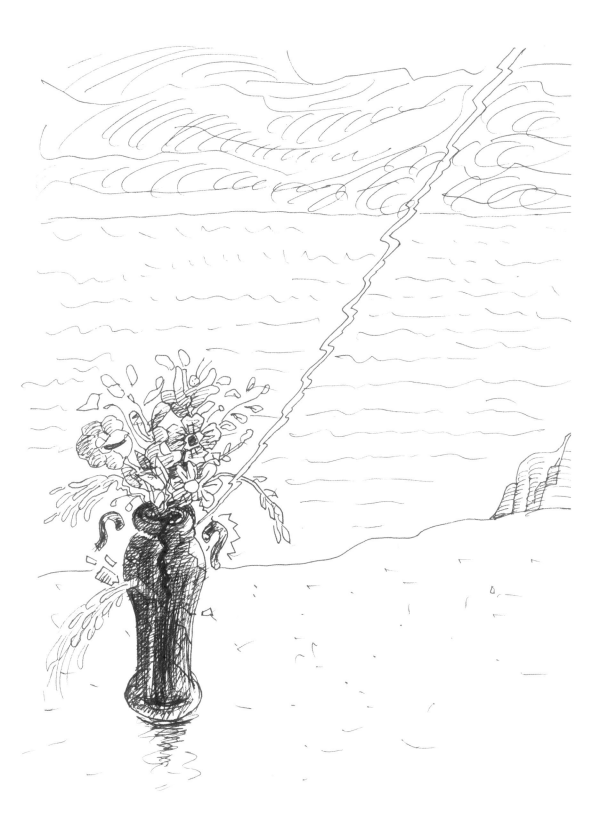

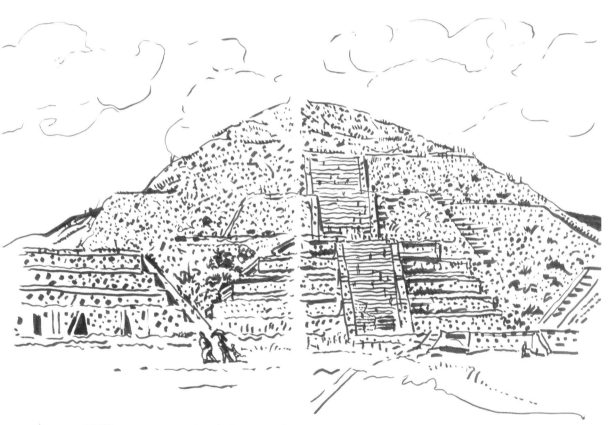

Sunday Temples of the Moon

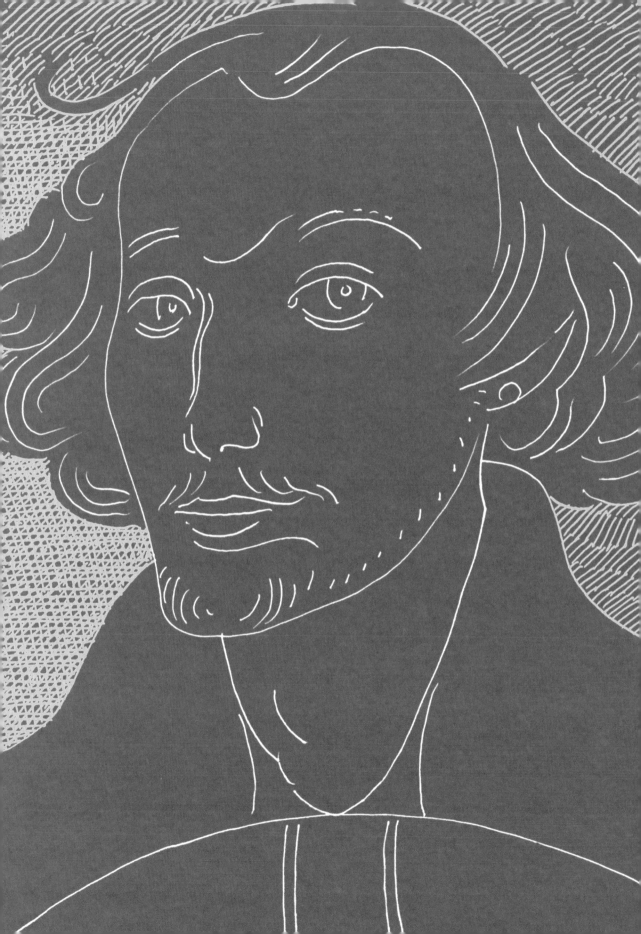

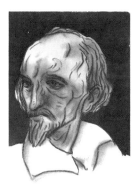

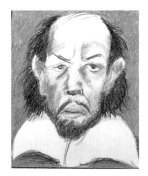
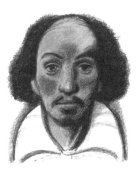
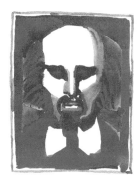
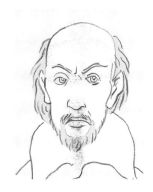
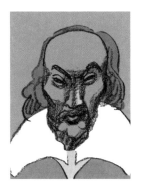
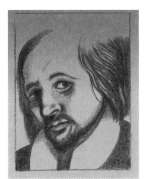
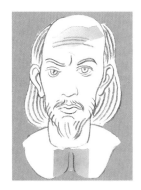

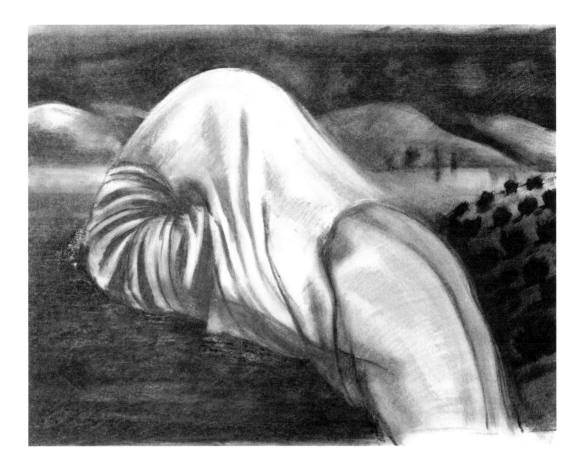

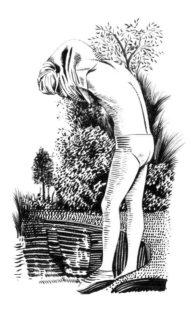

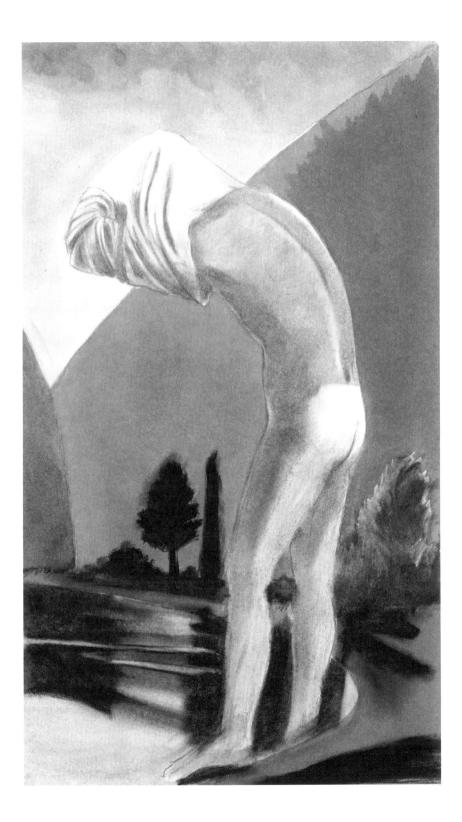

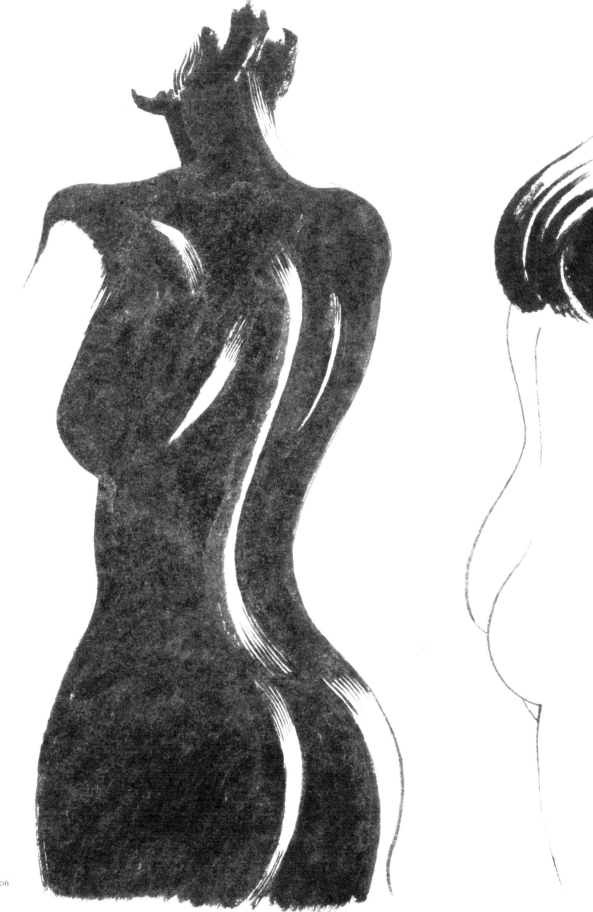

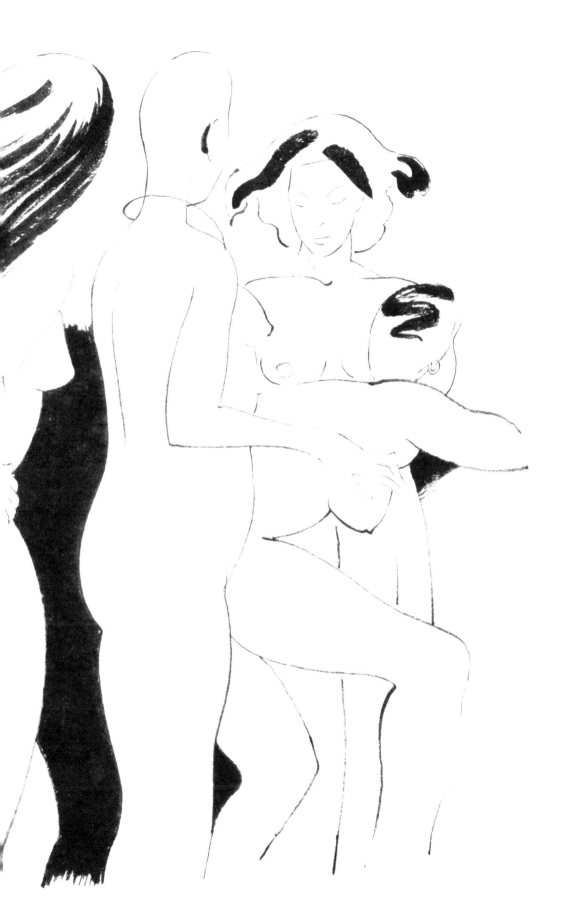

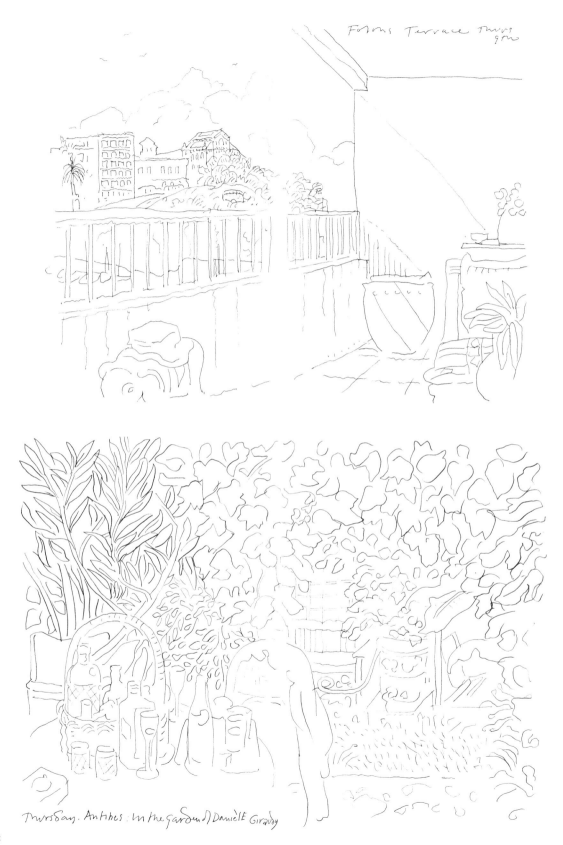

Fotons Terrace Thurs 9m

Thursday. Antibes. In the garden Danielle Giraudy

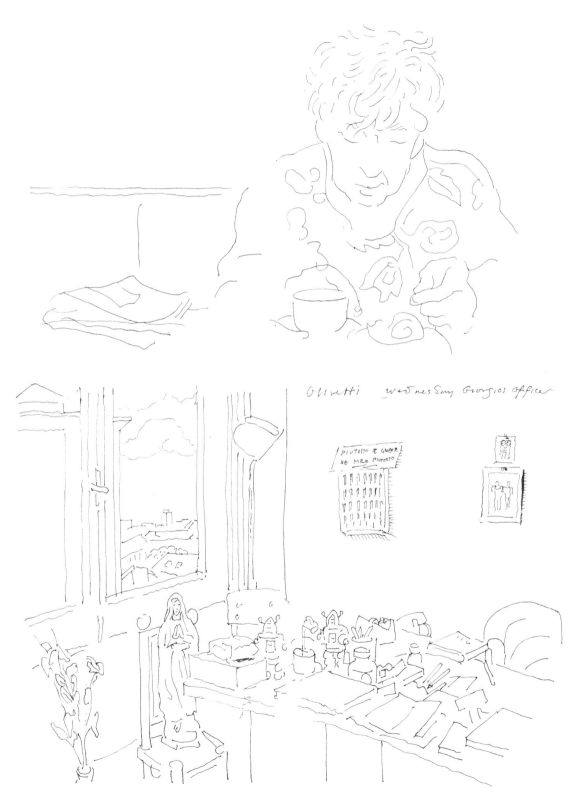

Olivetti Wednesday Georgios office

PIUTOSTO PE GWERR
XE MEJO PIUTOSTO

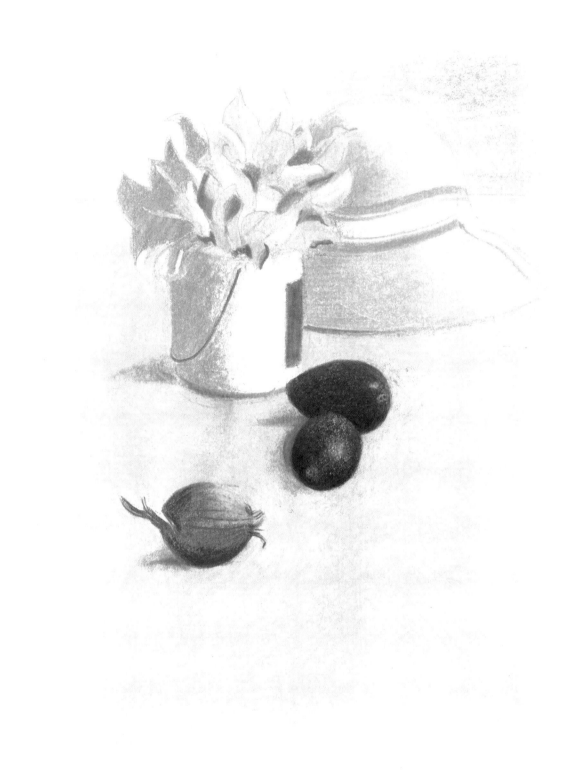

Thursday

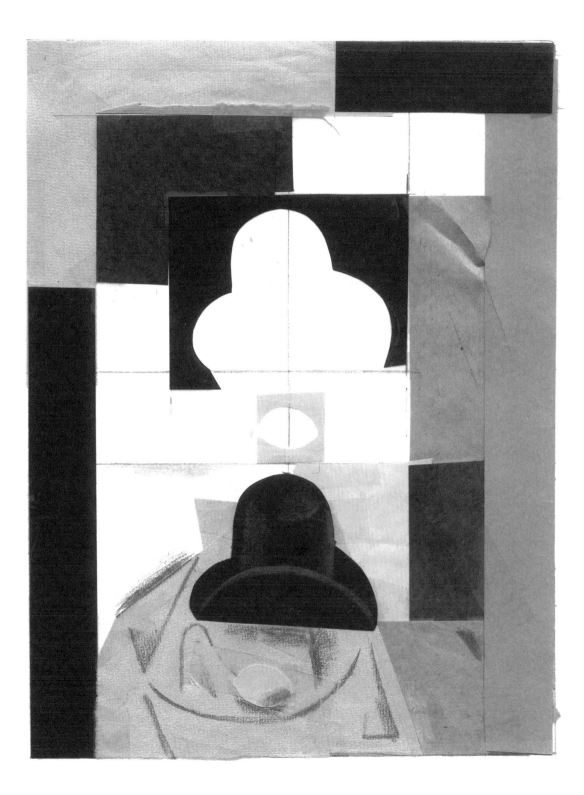

Thurs A Drink in Greece

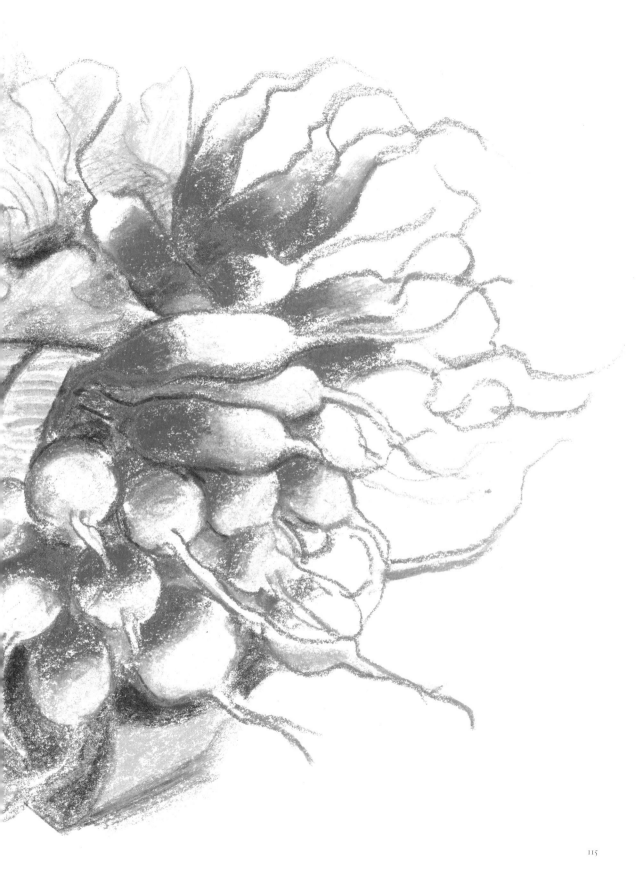

Saturday in Fes. View from our room at Palais Ja

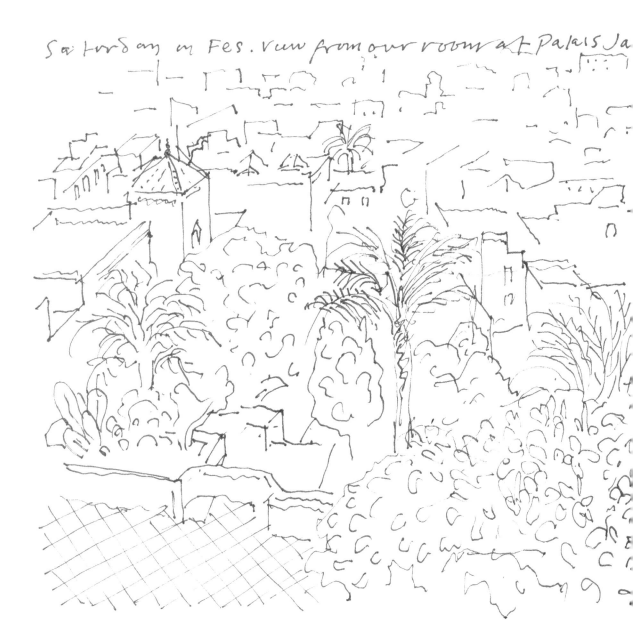

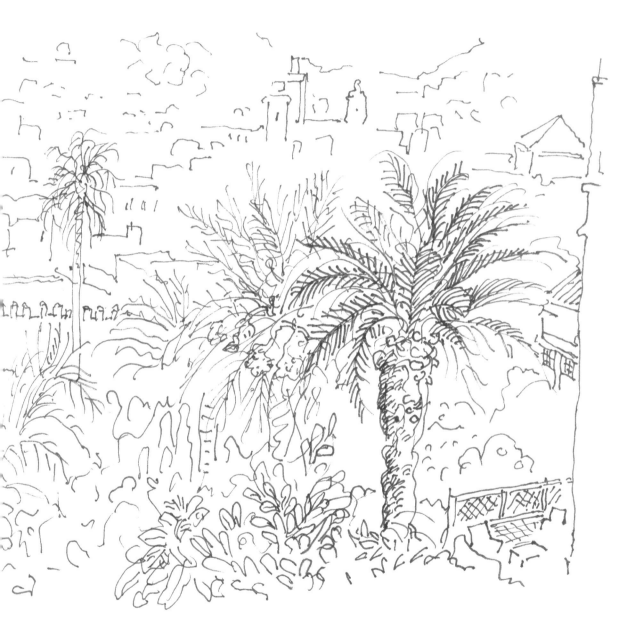

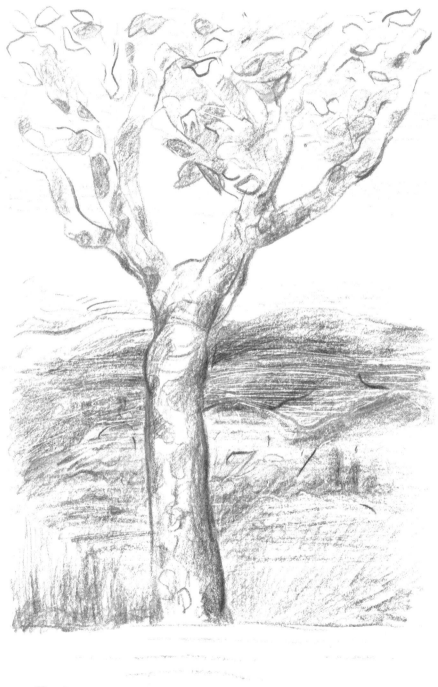

Dresden

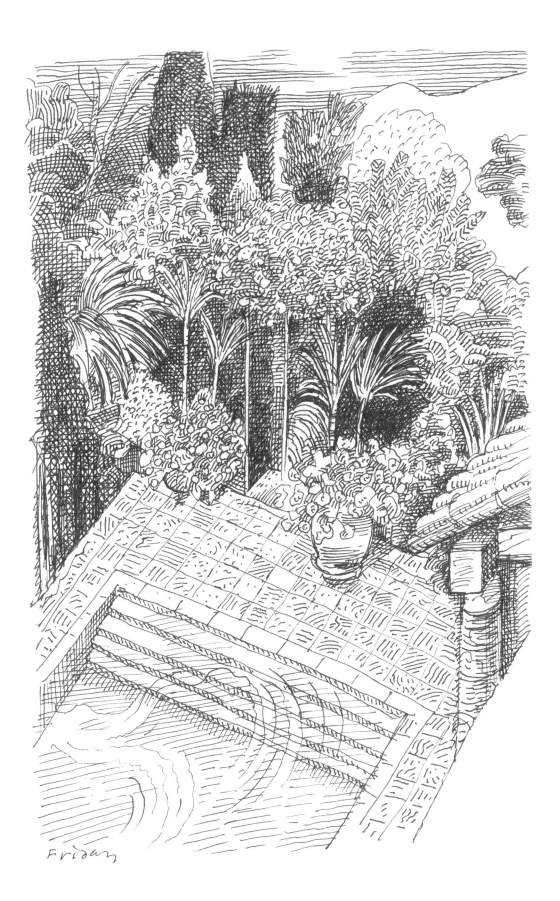

Friday

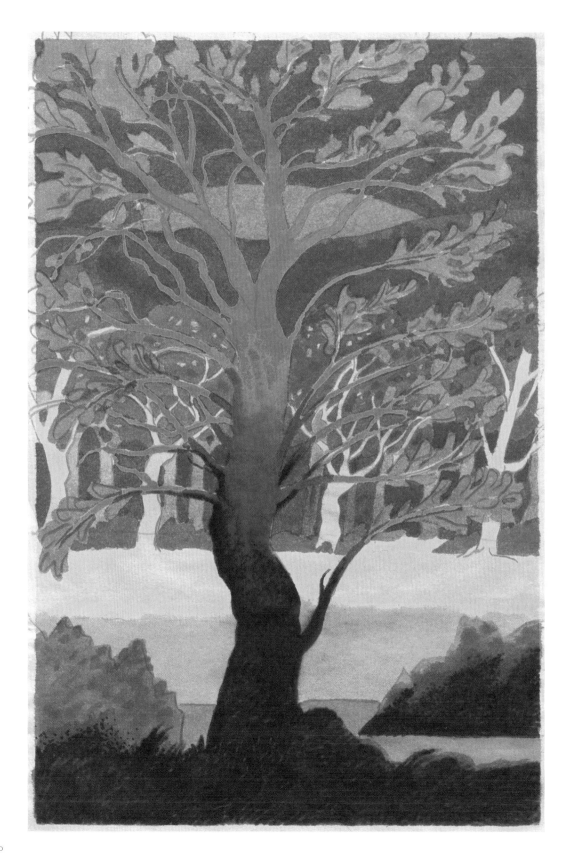

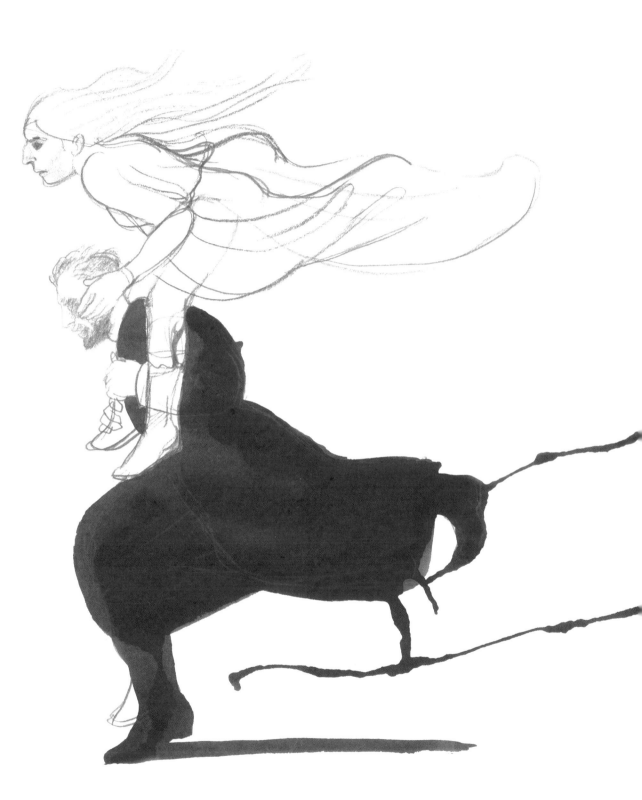

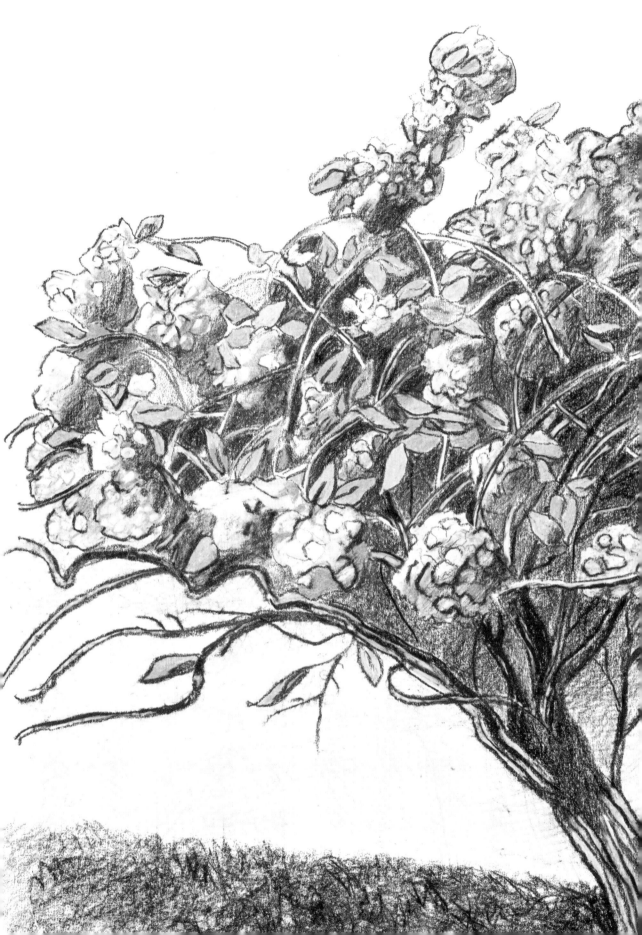

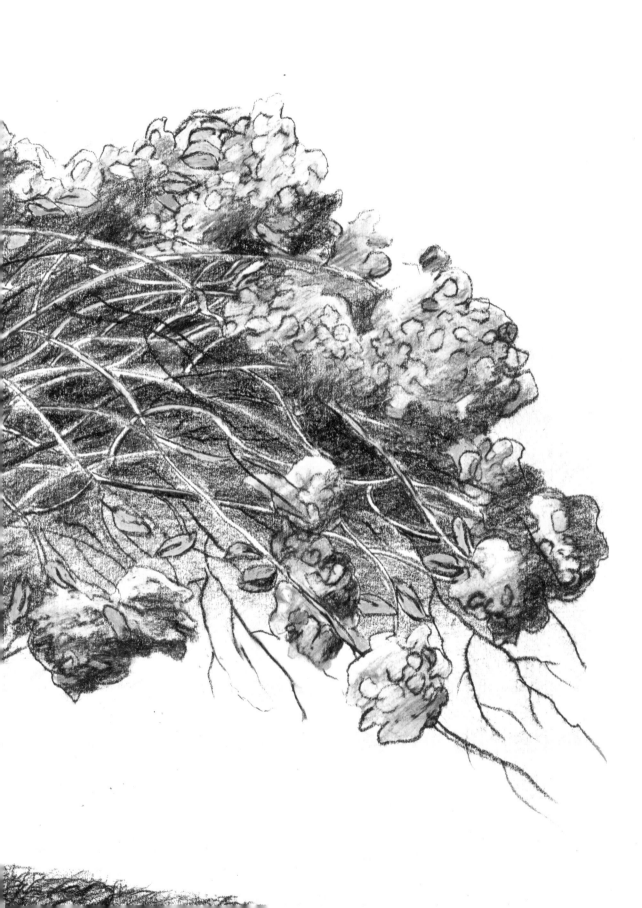

A cheese extravaganza
at Soavi's table at home.

For lunch
spaghetti con Milano Nov 22
verdura = (brocholetti rape)
we drank lambrusco rose = A
surprise - quite dry sparkling wine

truffles Pear Gorgonzola
 Grapes

pistachio

Nuts

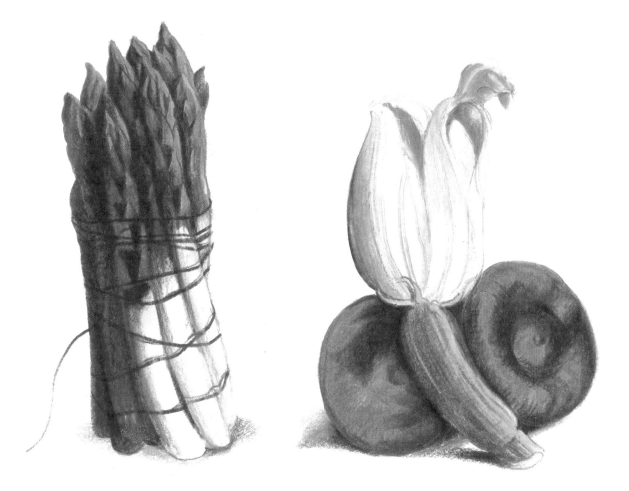

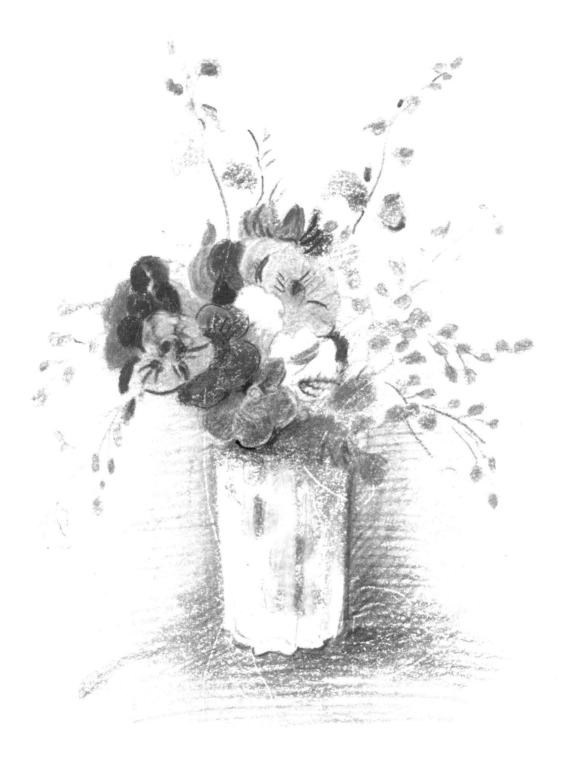

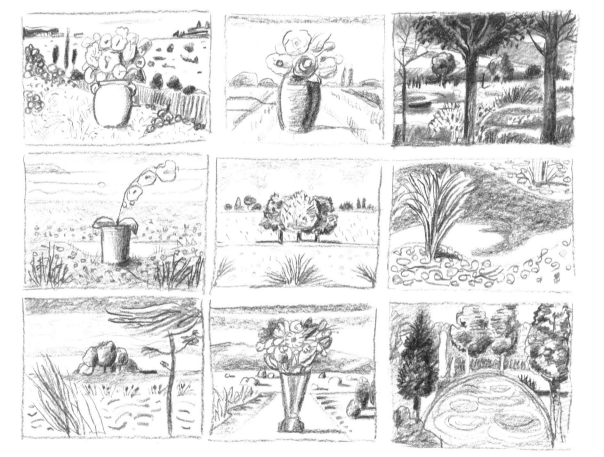

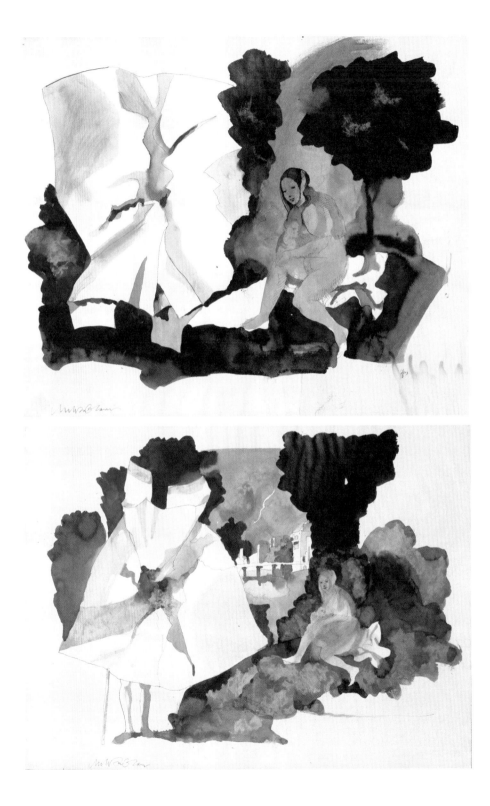

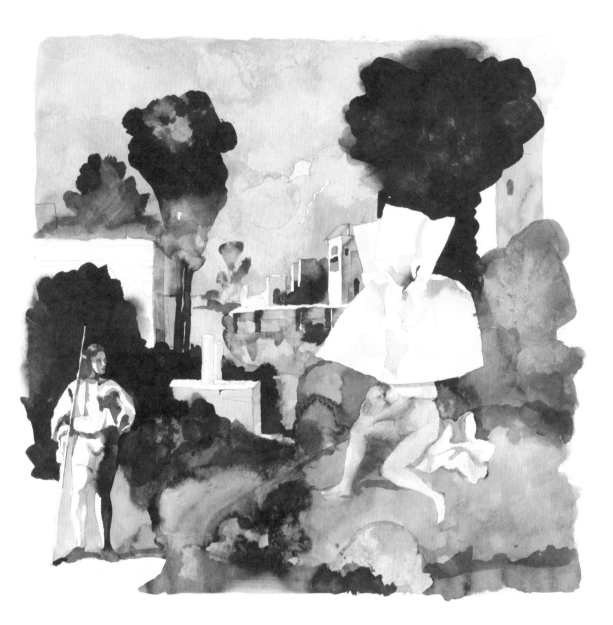

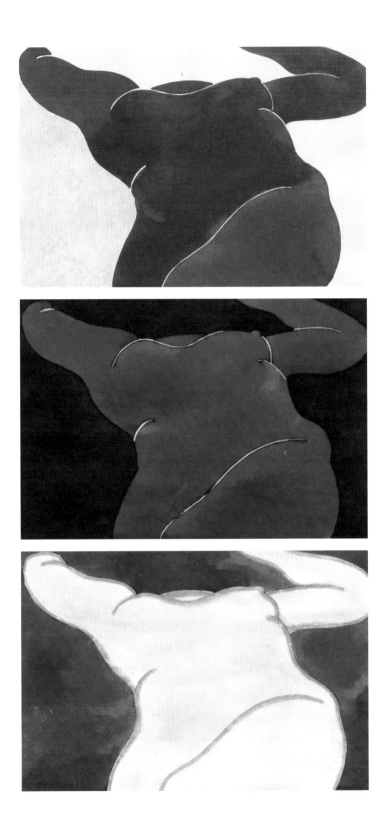

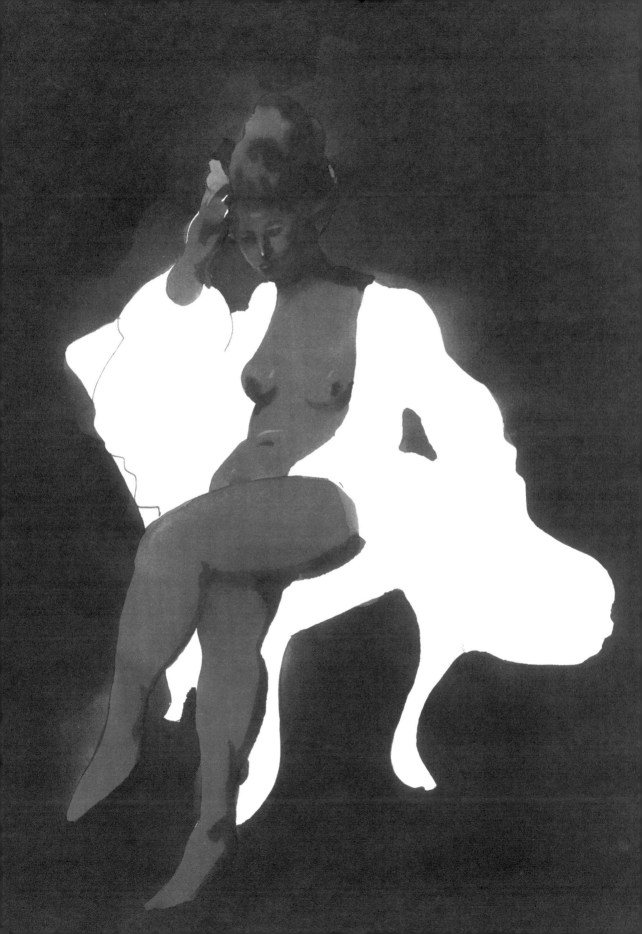

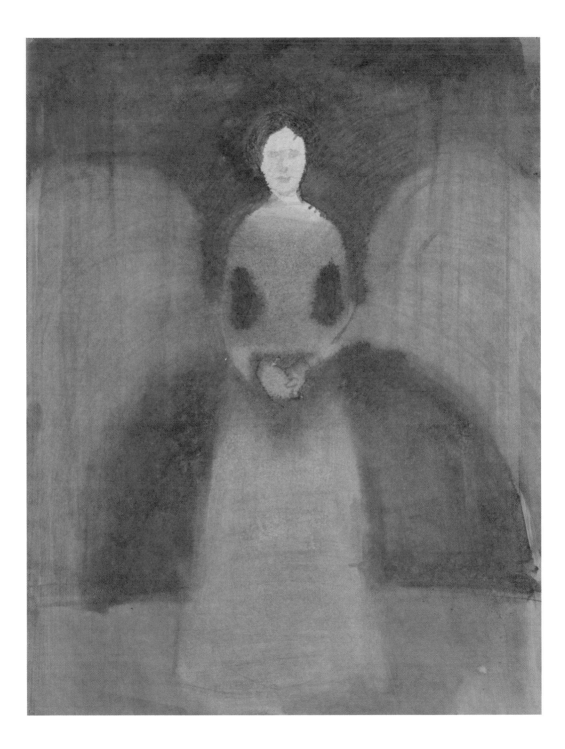

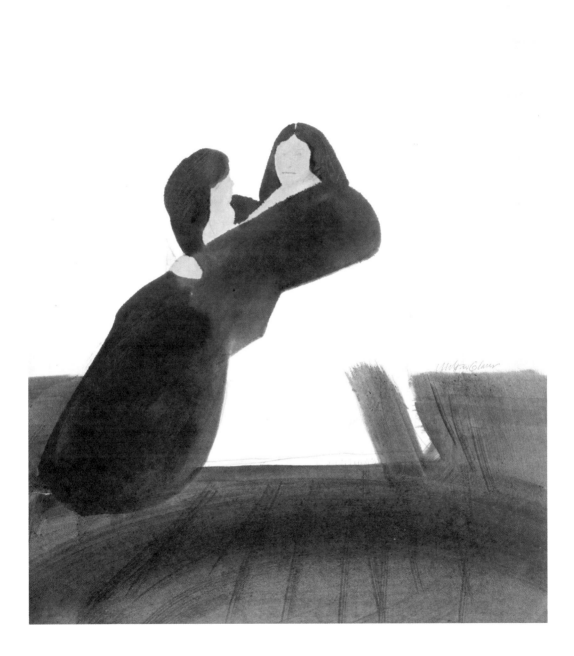

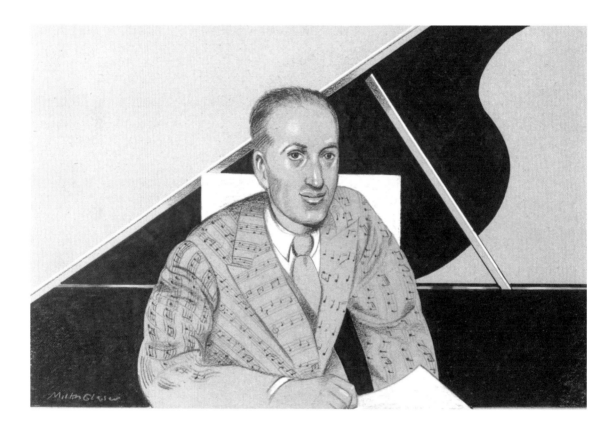

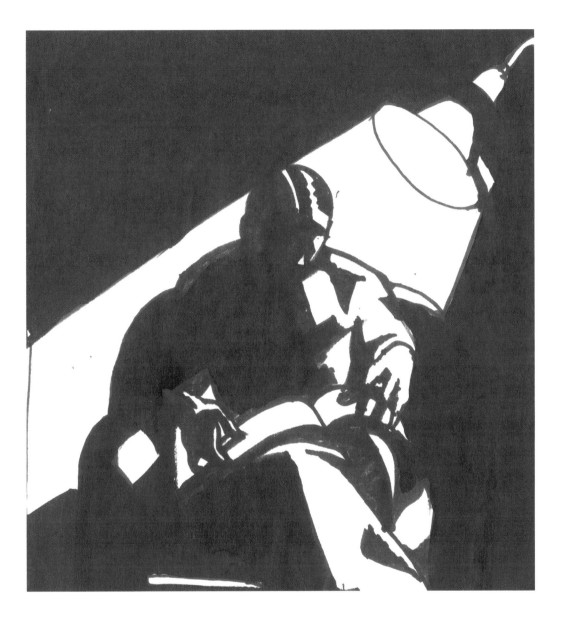

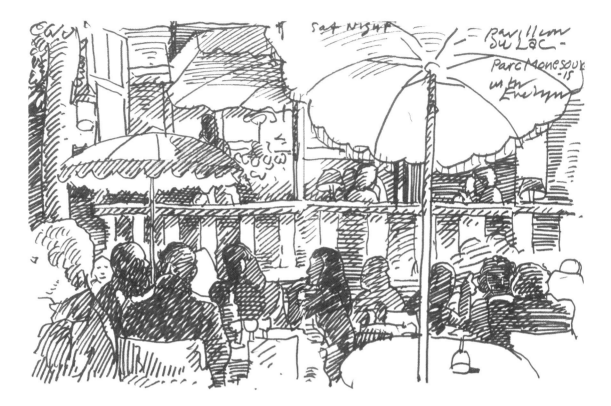

Spoiled child at Prevos Friday

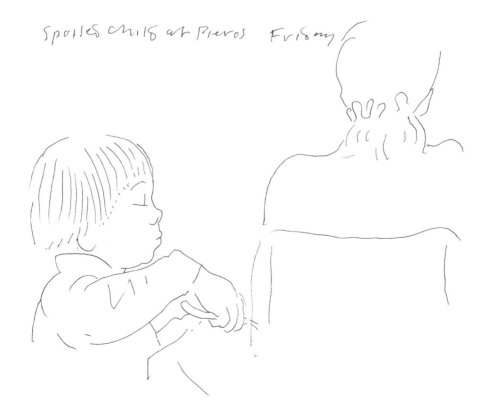

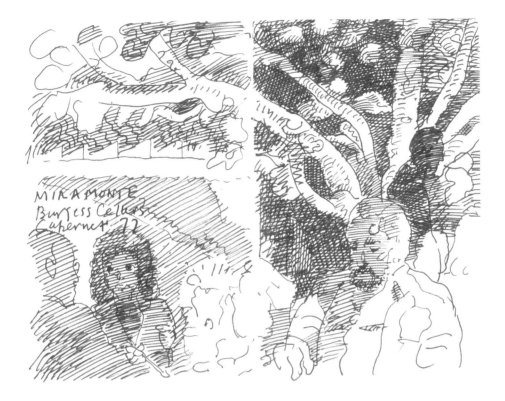

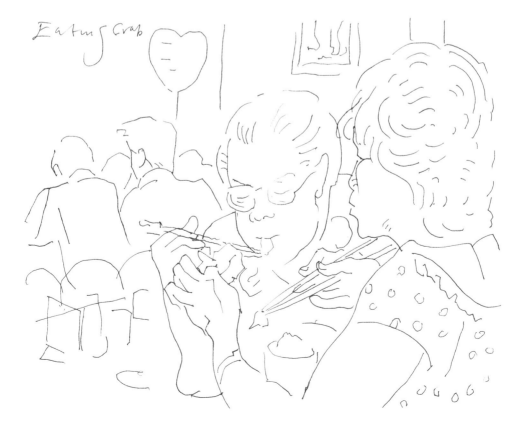

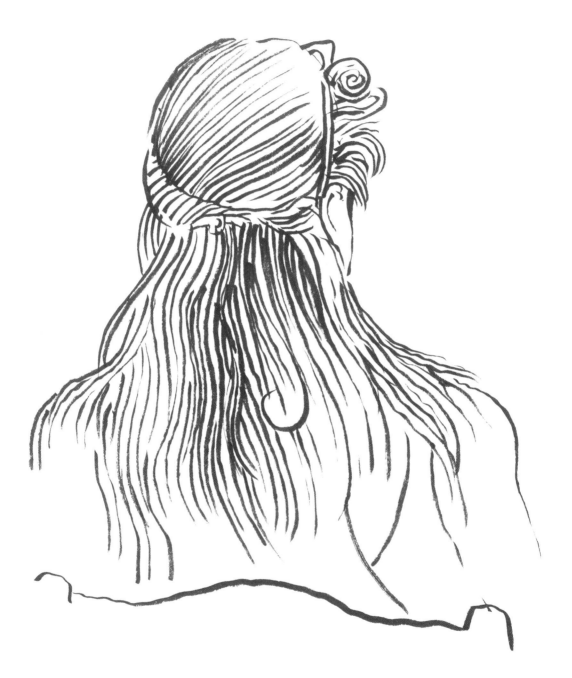

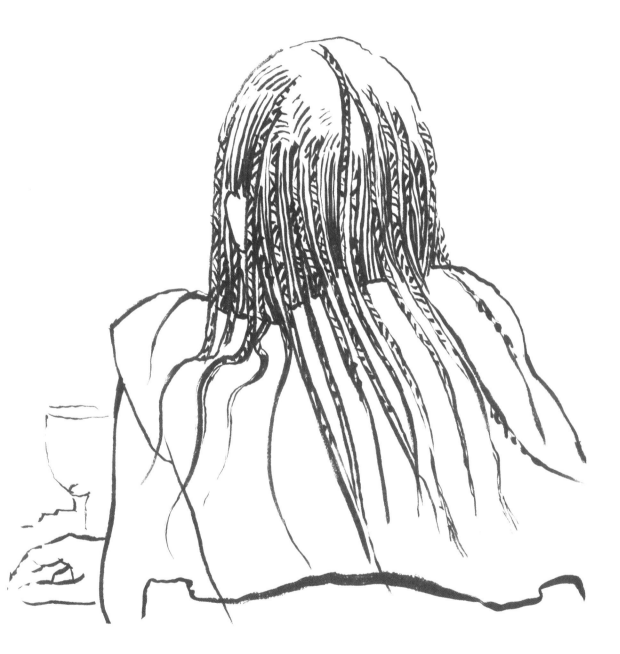

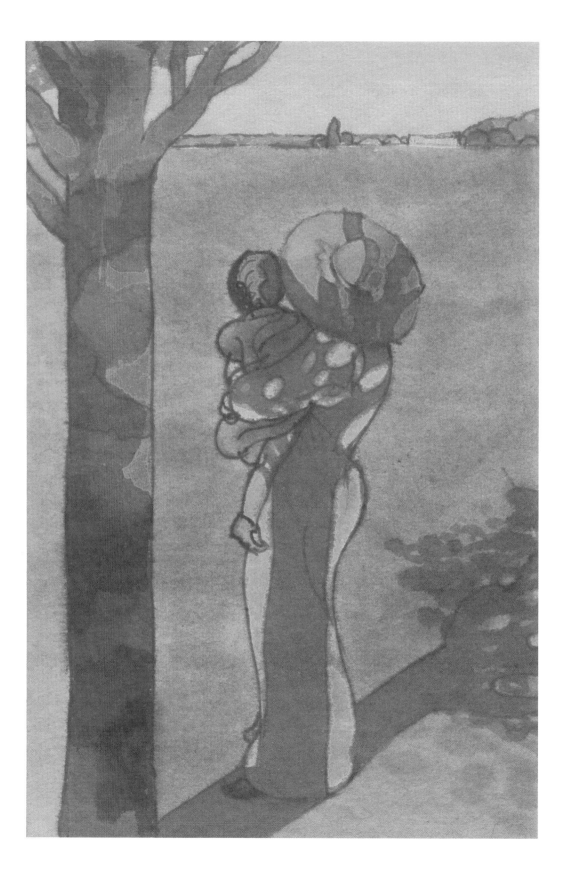

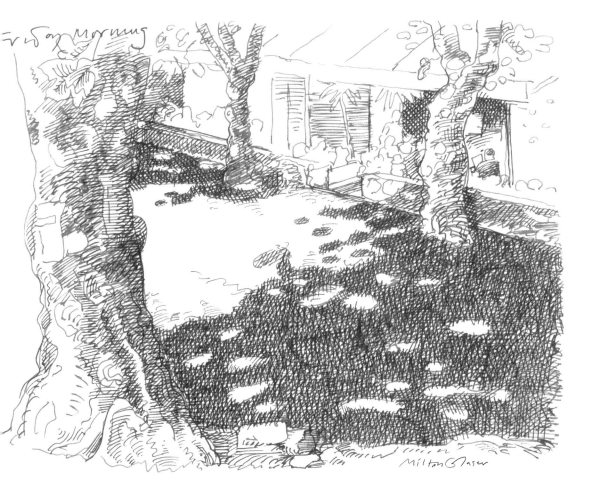

Friday Morning

Milton Glaser

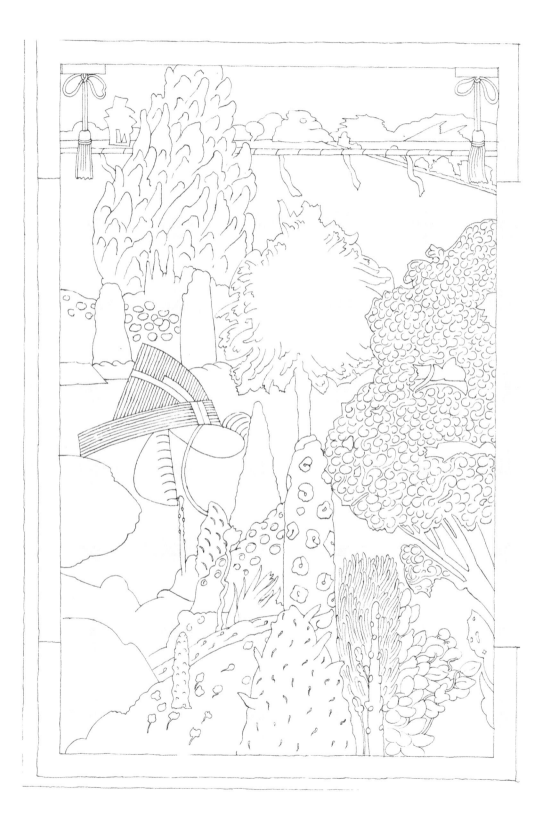

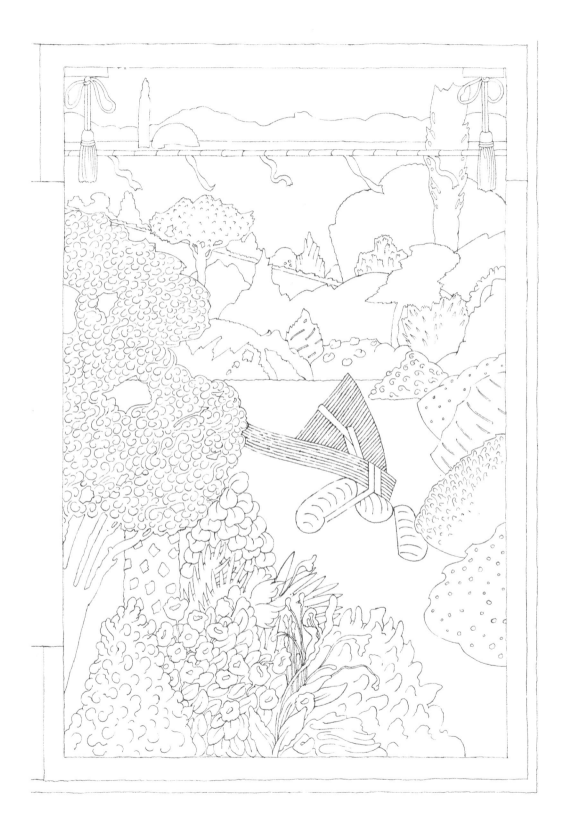

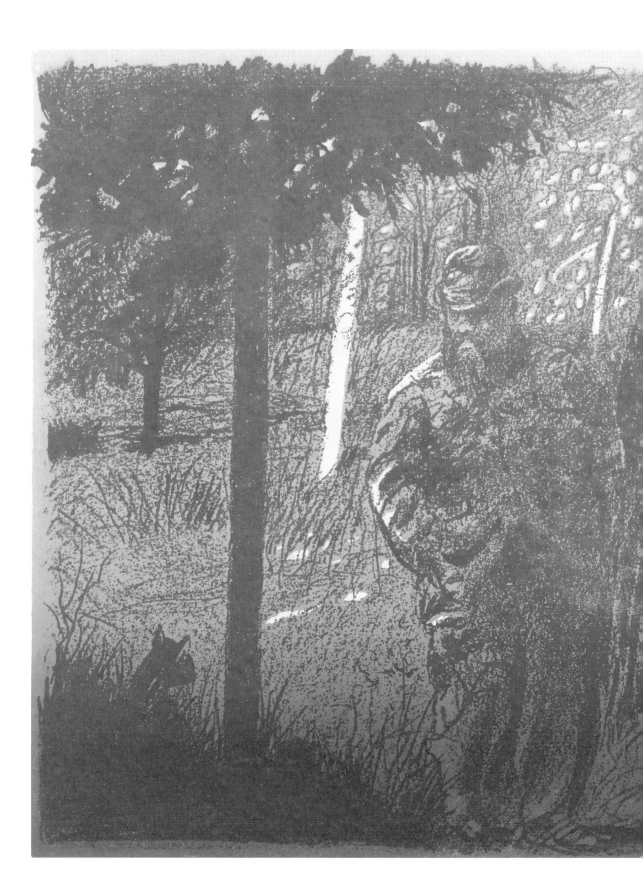

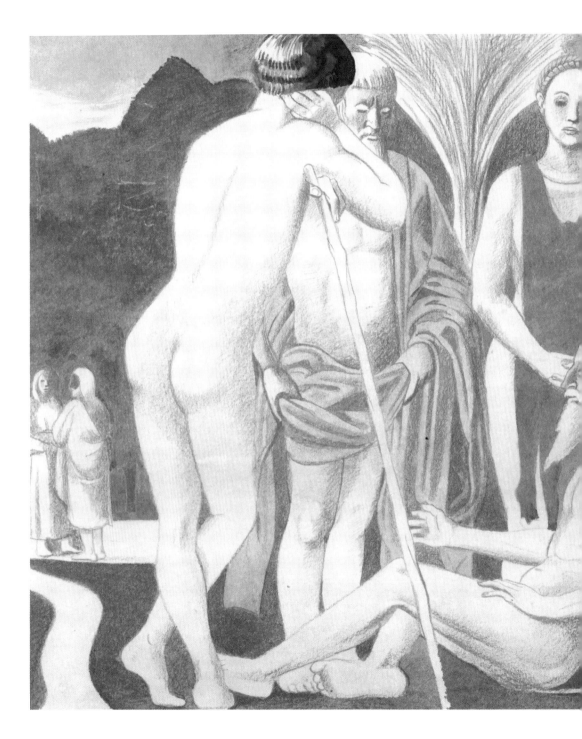

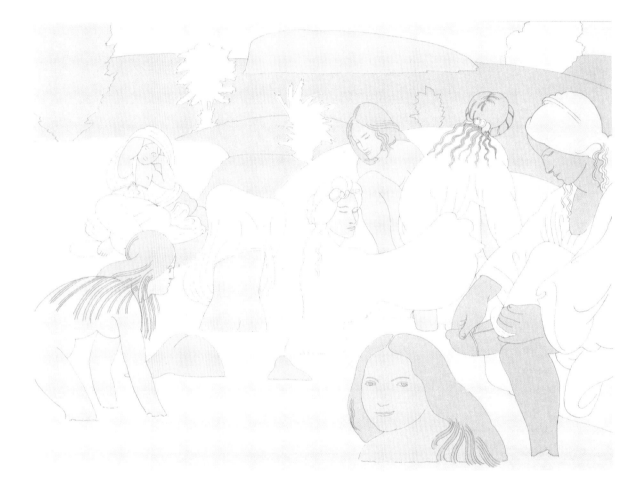

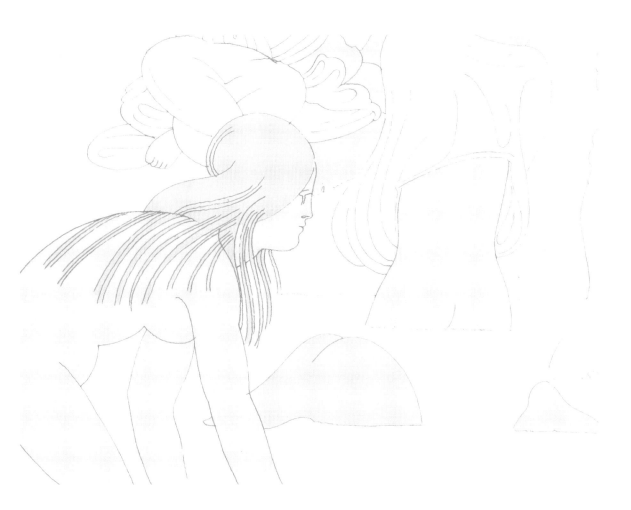

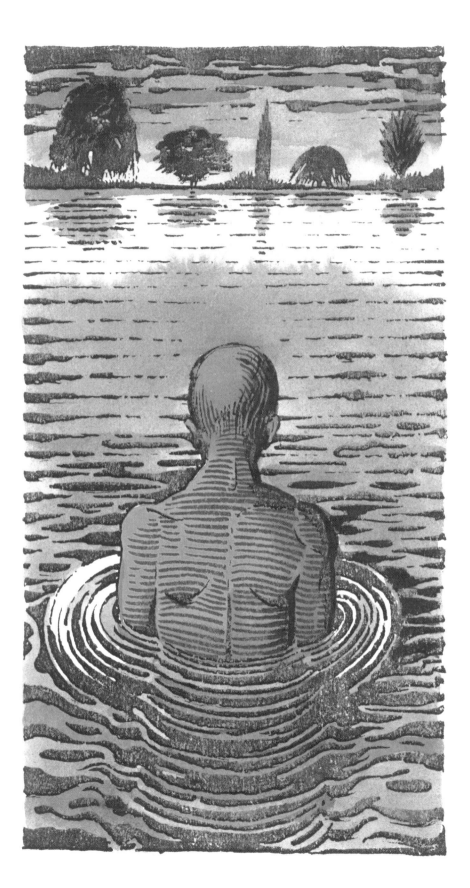

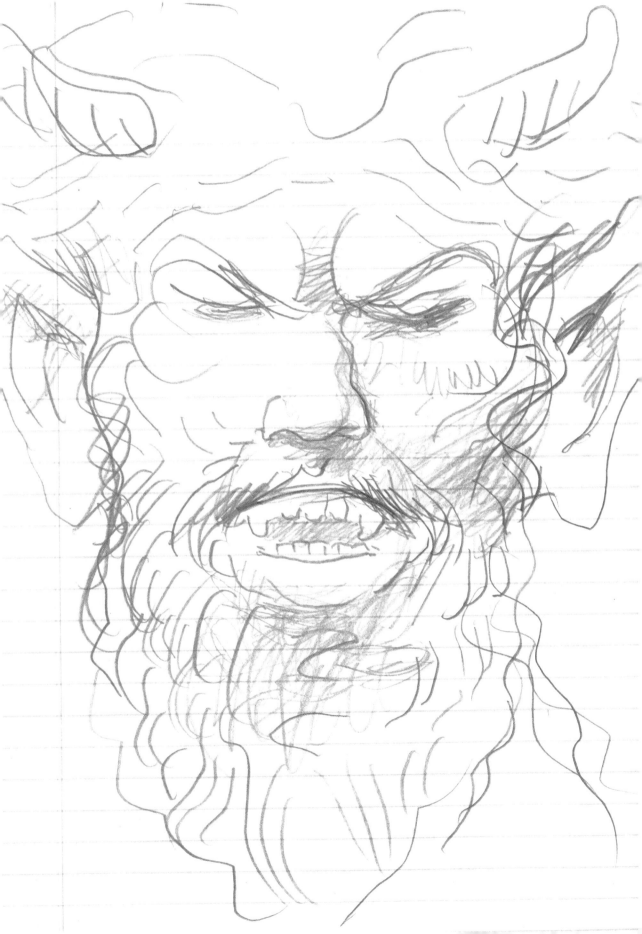

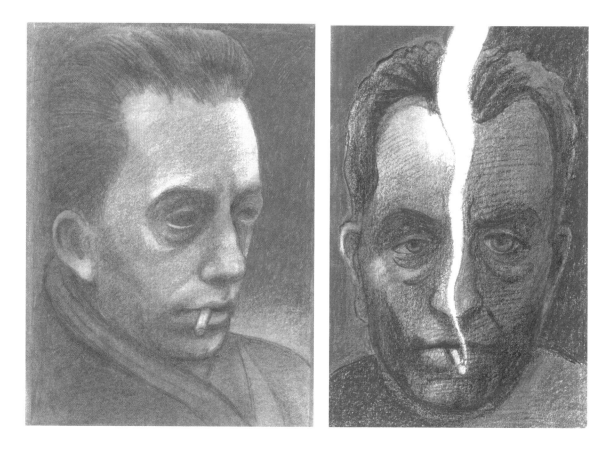

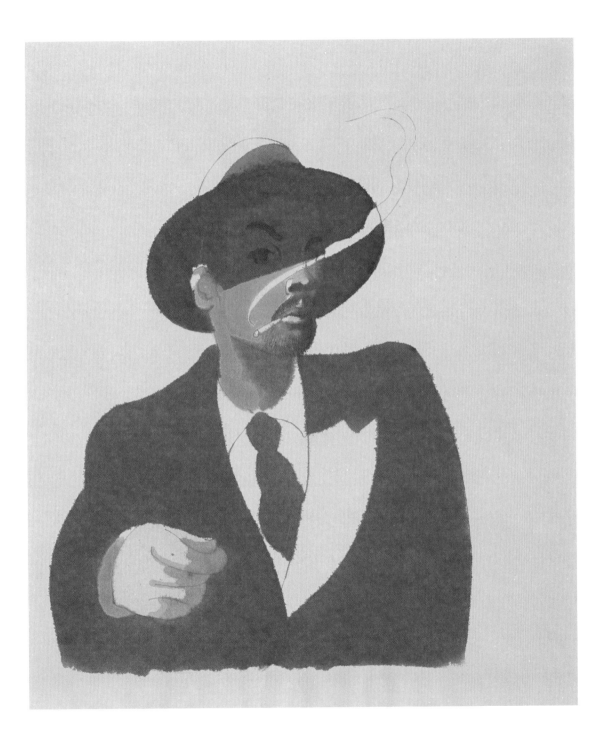

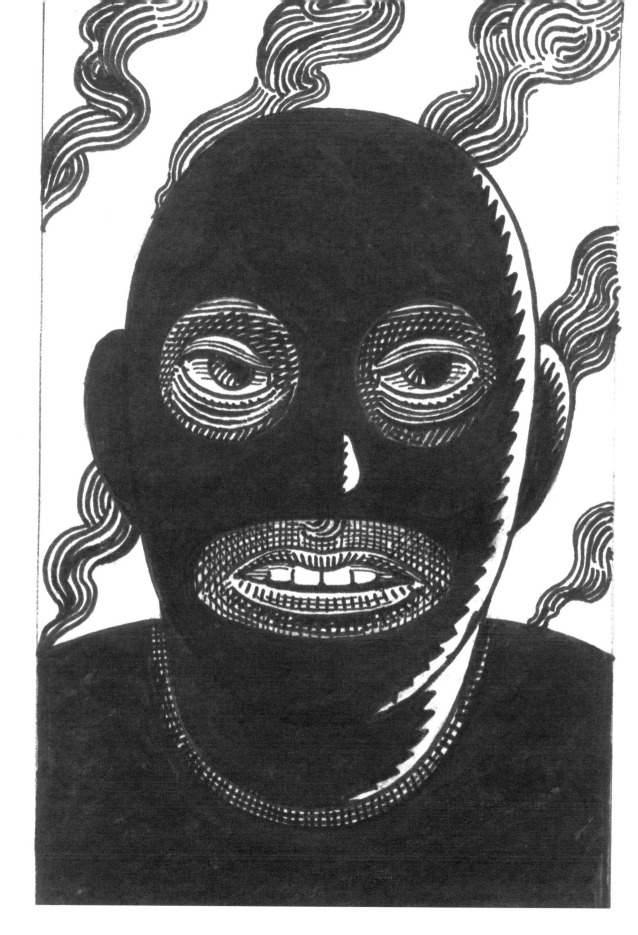

JOYSPRICK

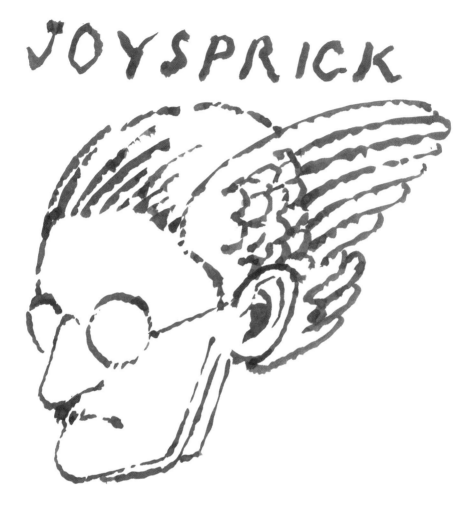

The Great Wines authority

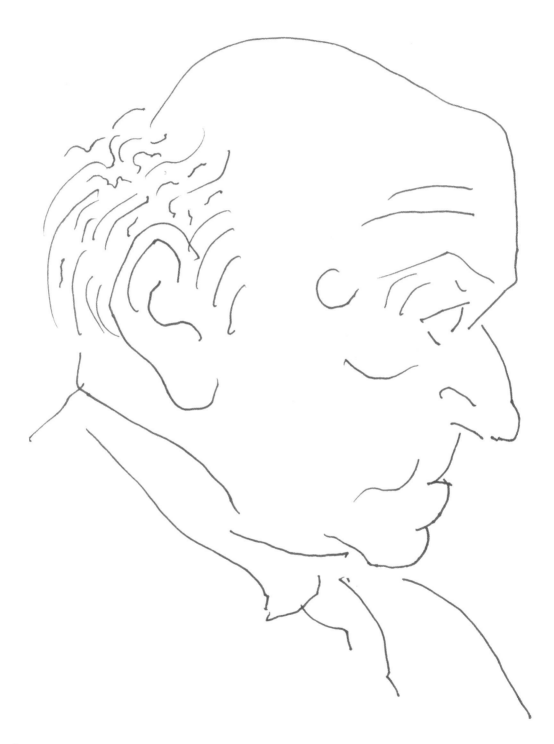

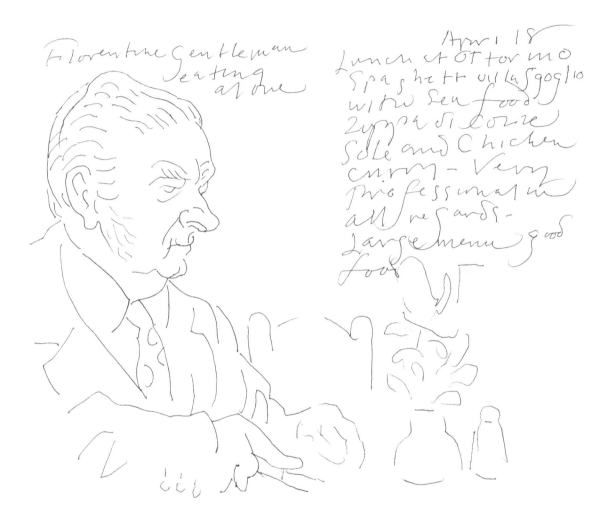

Florentine Gentleman
eating
alone

April 18
Lunch at Ottorino
Spaghetti villasgoglio
with Seafood.
Zuppa di cozze
Sole and Chicken
curry — Very
professional in
all regards.
Large menu — good
food

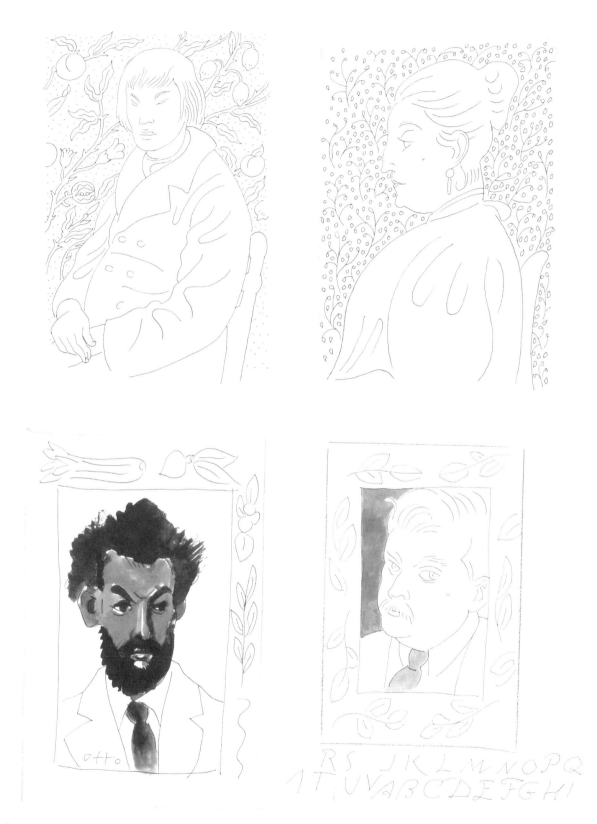

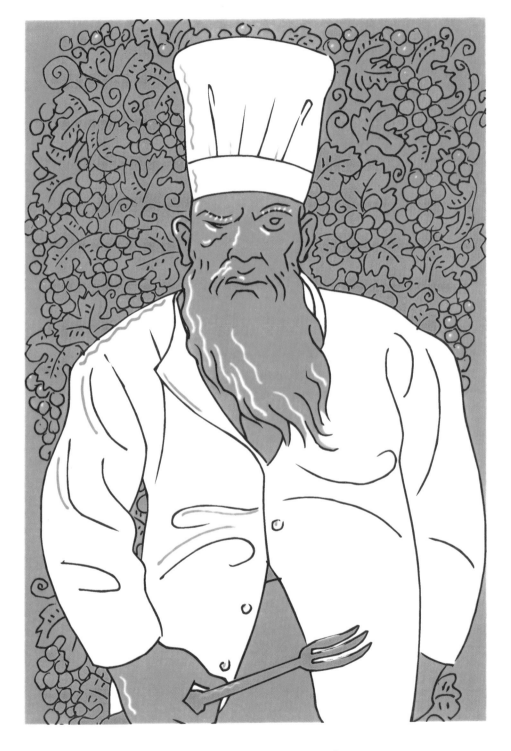

Francois

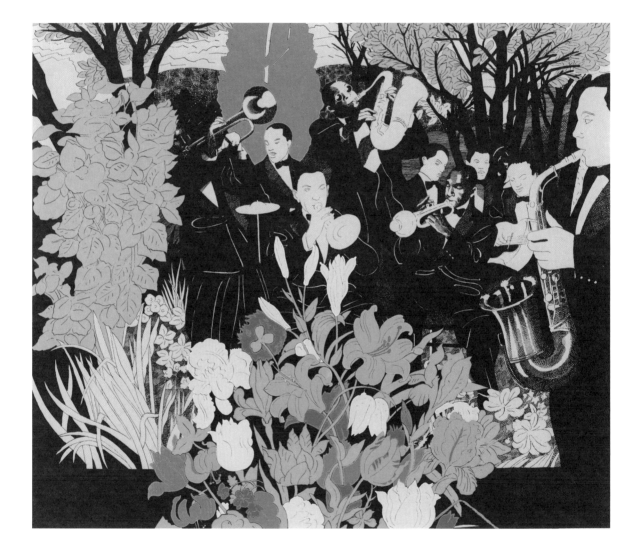

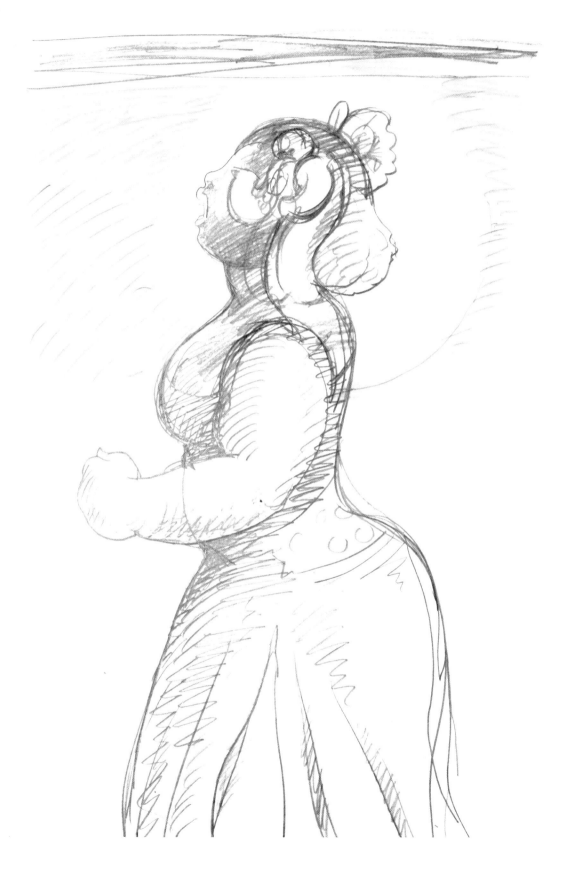

163

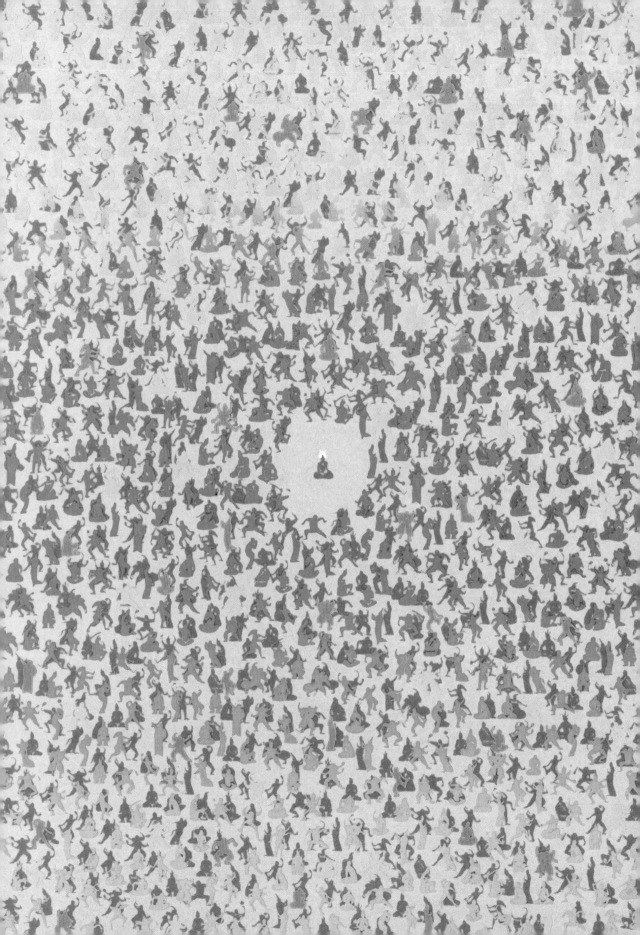

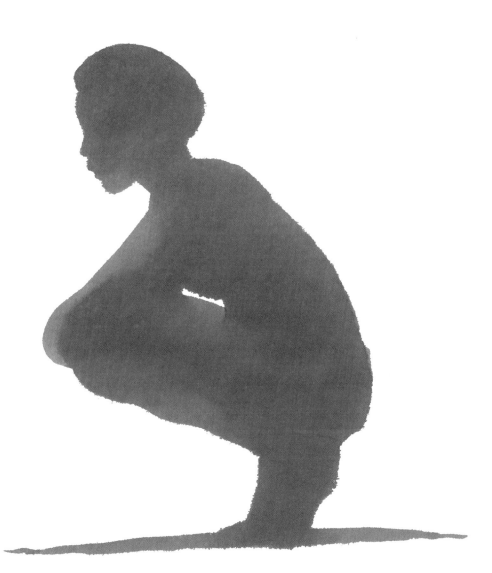

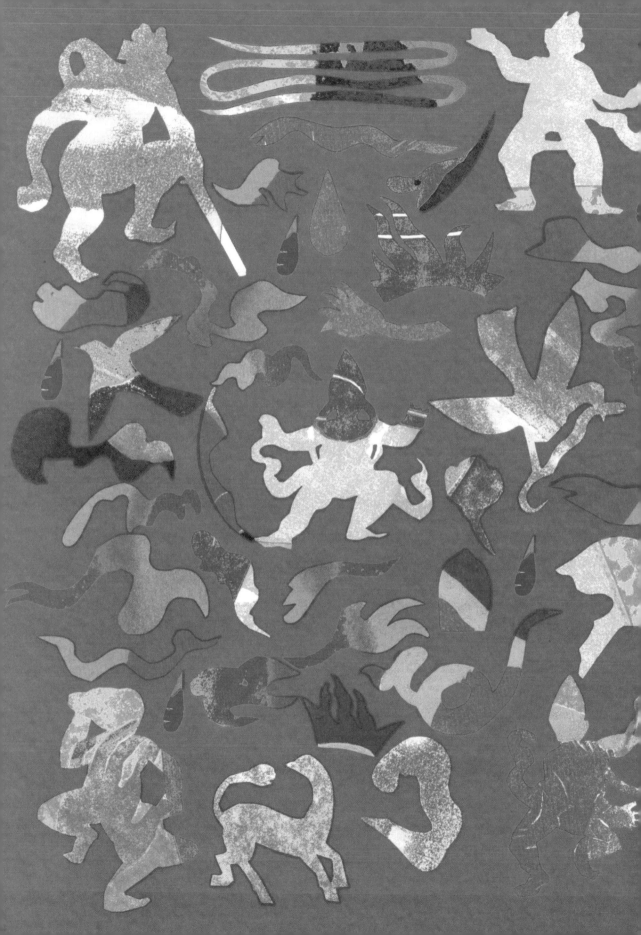

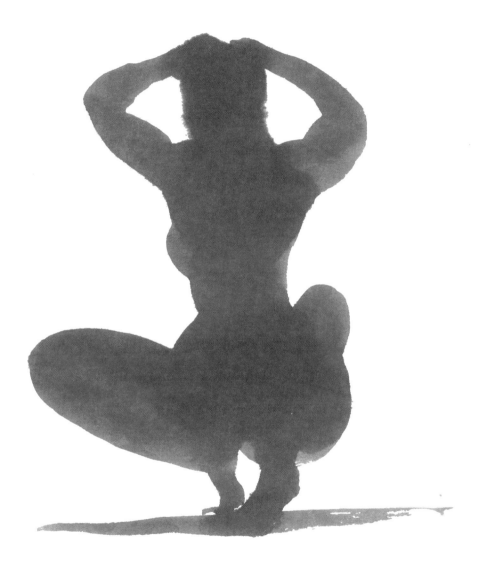

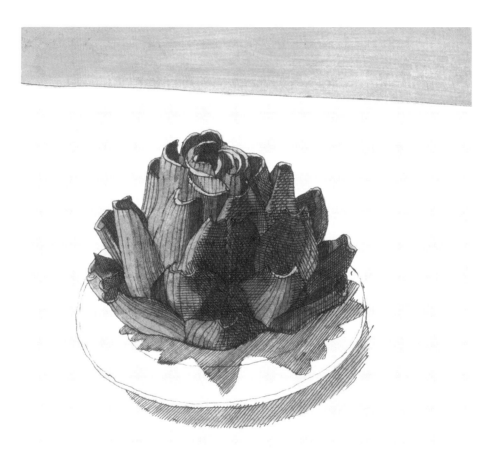

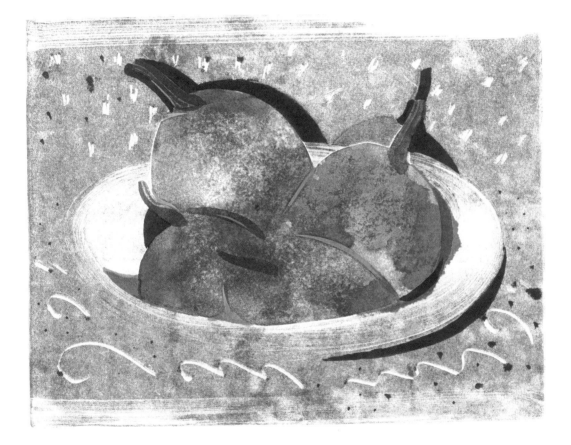

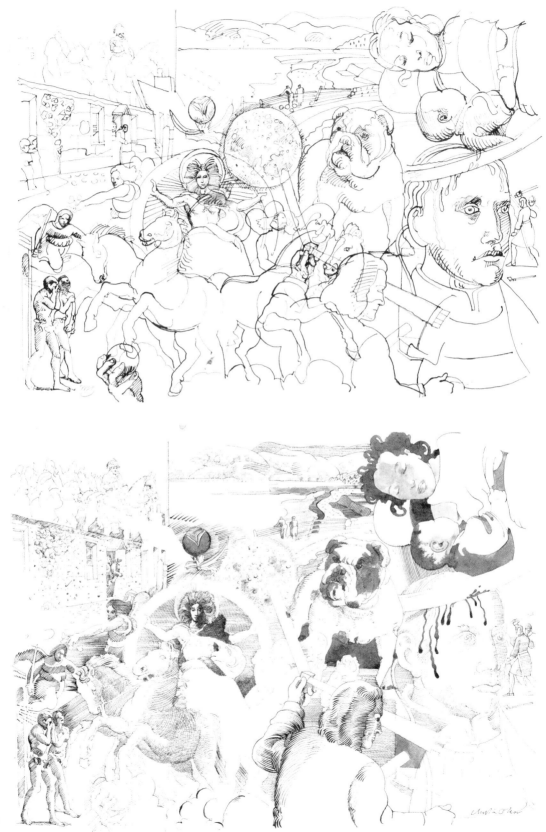

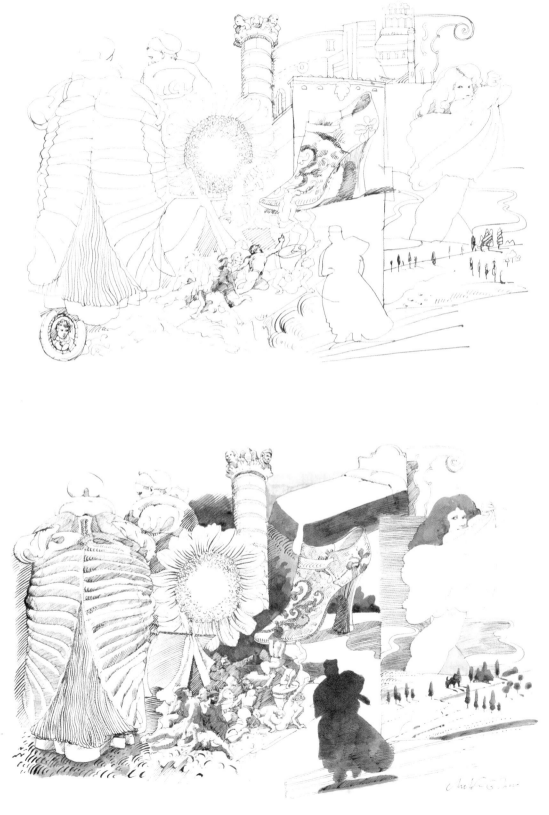

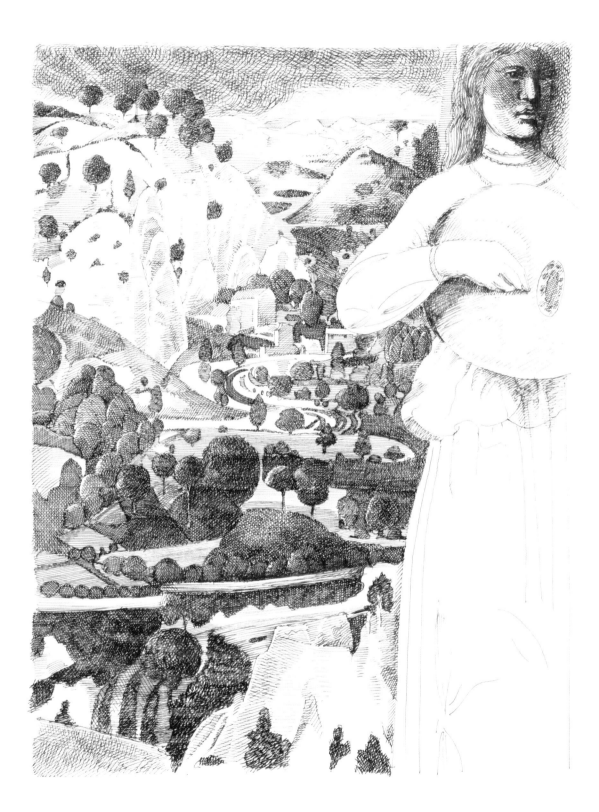

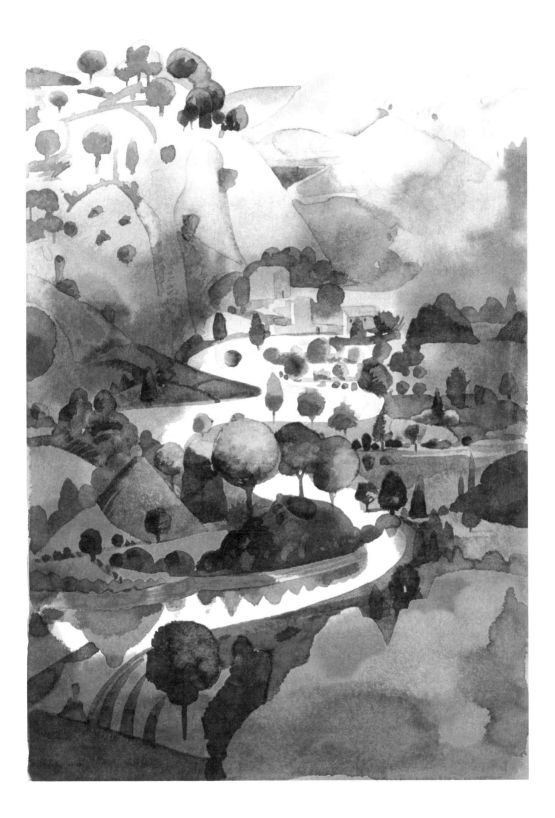

Sagrada Familia

The view from coffee

mers

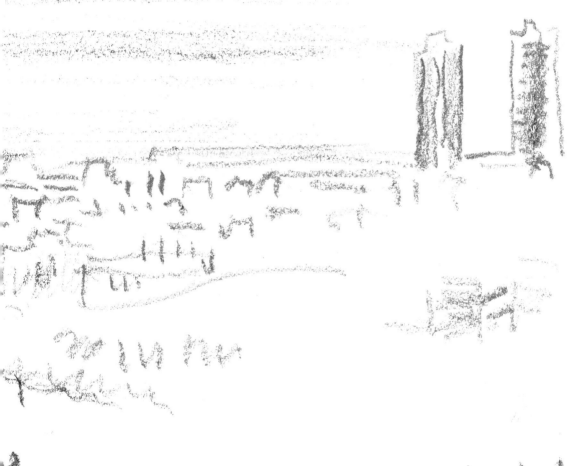

our hotel

nop outside La Vence

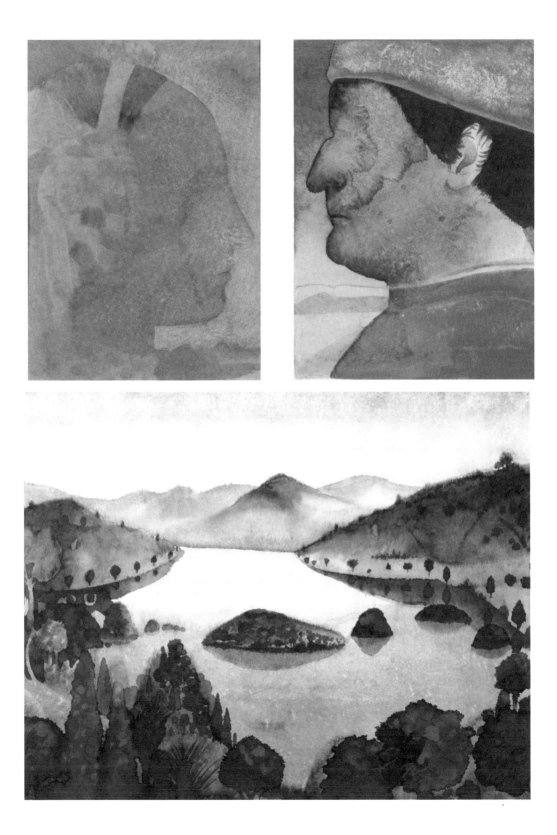

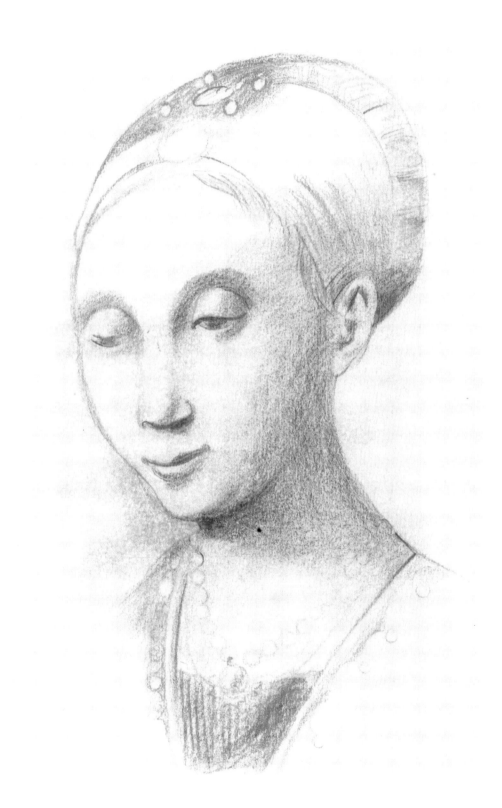

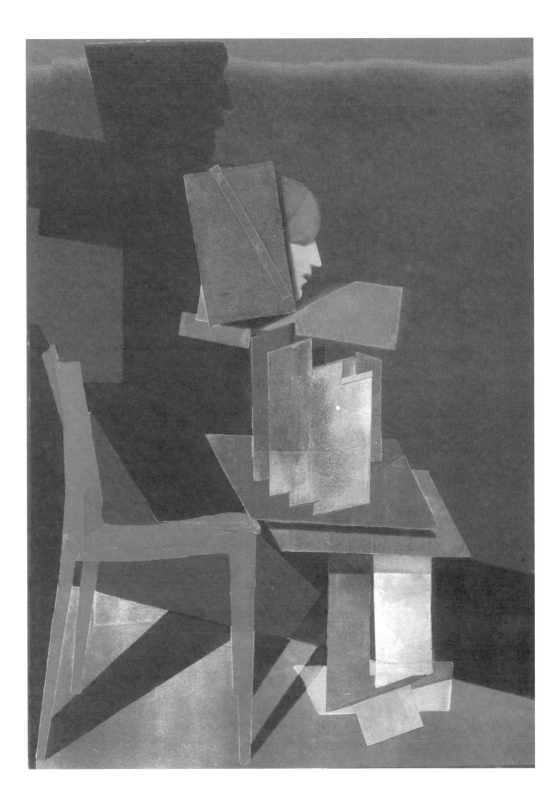

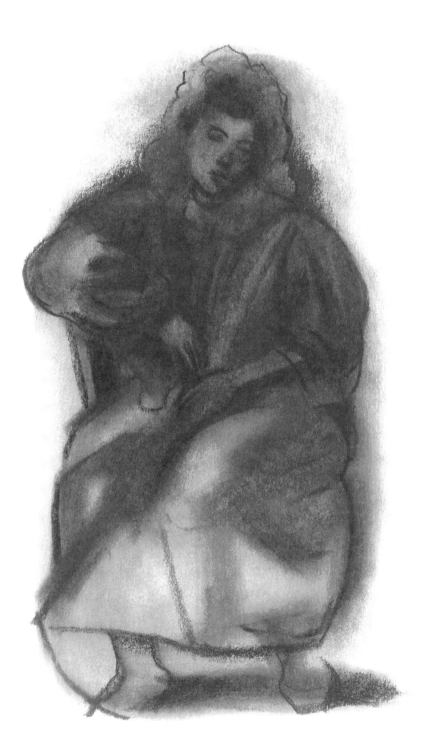

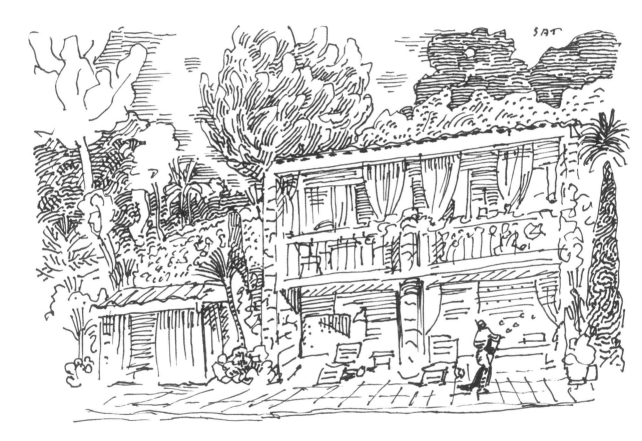

FriSan April 21, View from our window at
Hotel villa Michel ans gelo.

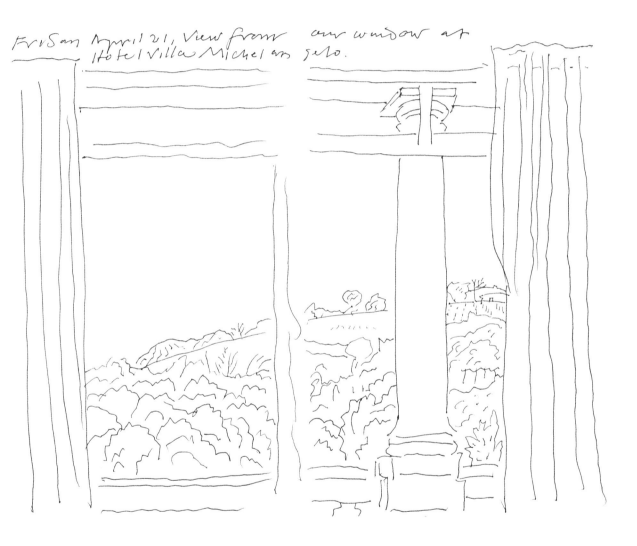

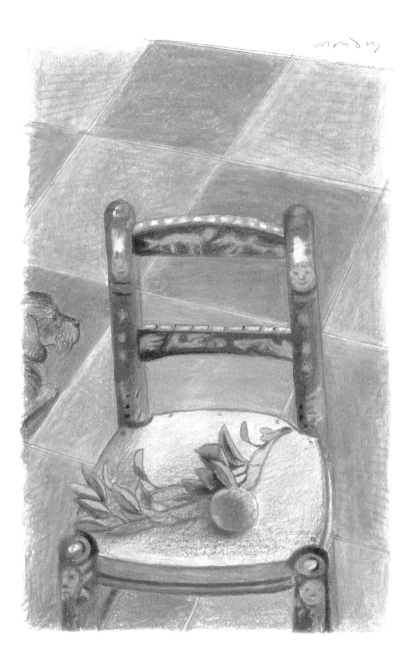

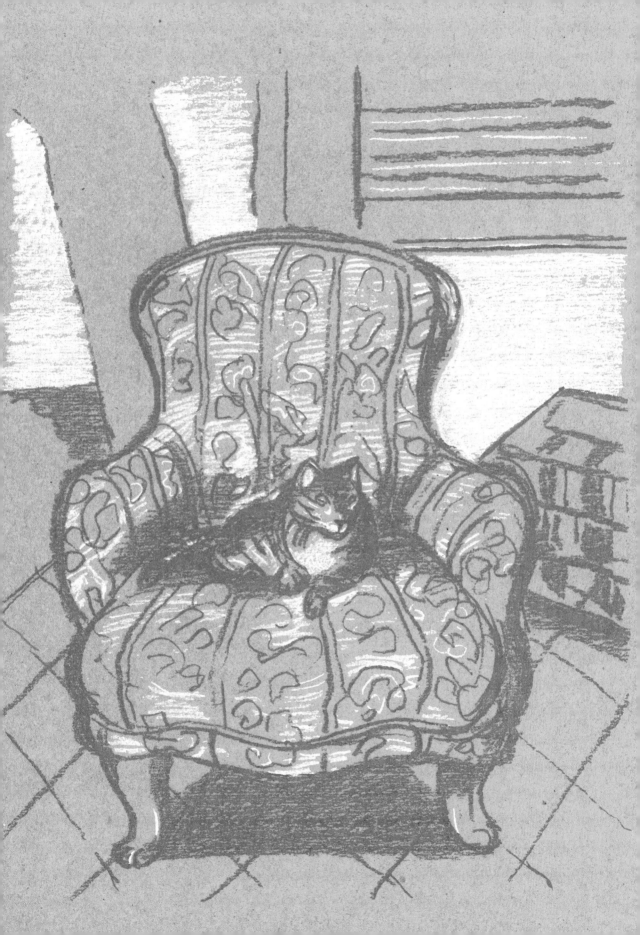

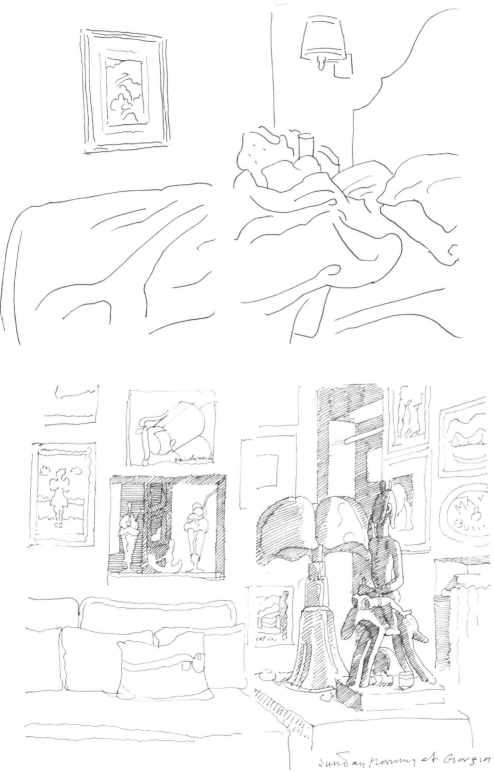

our room is very tiny

Sunday morning at Giorgio's

184

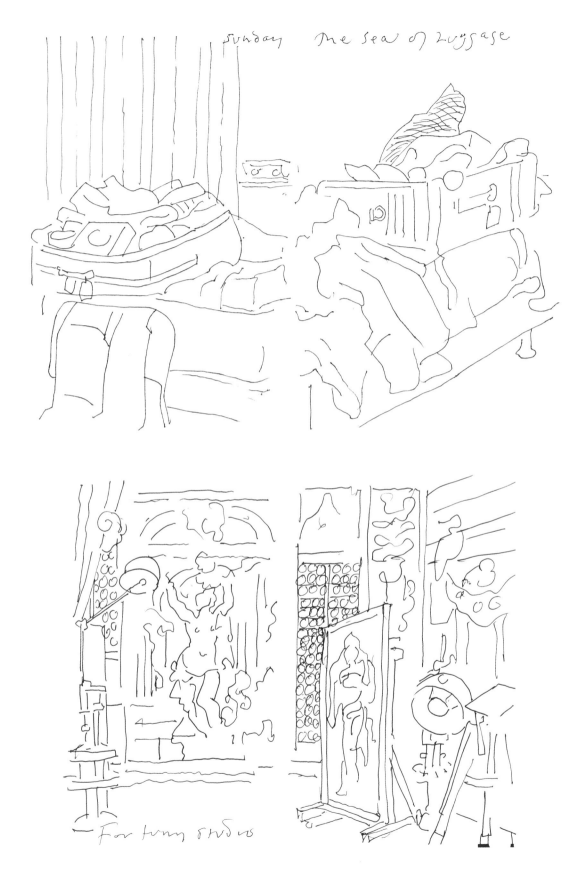

Sunday The sea of luggage

For funny studies

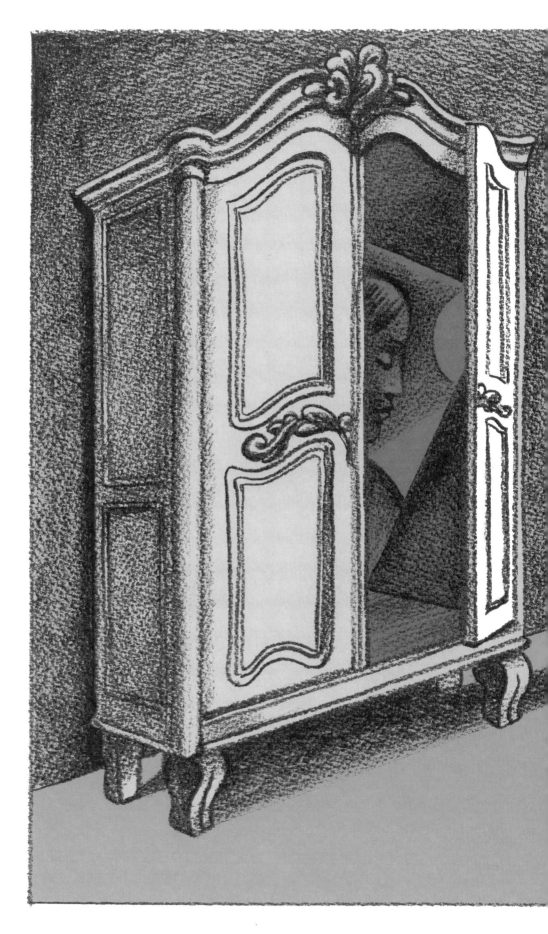

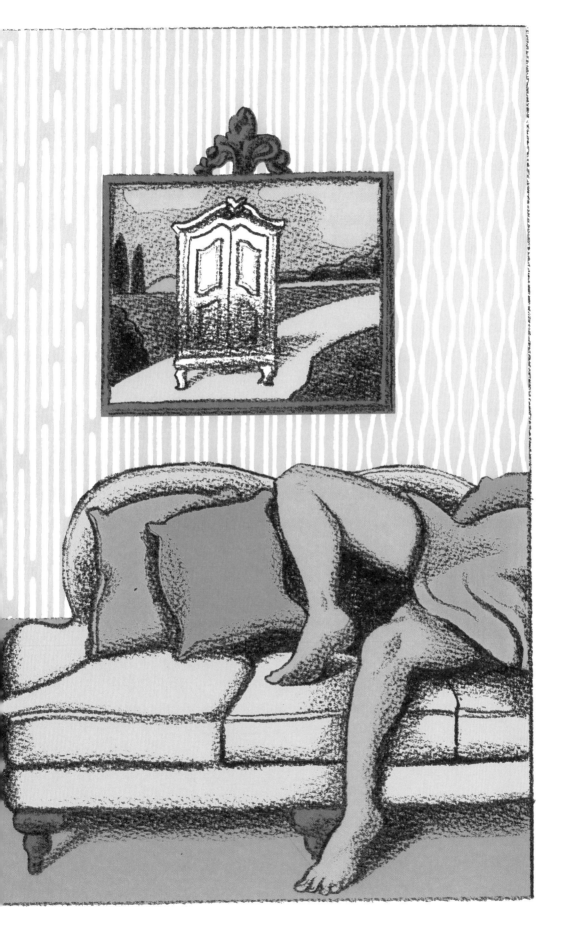

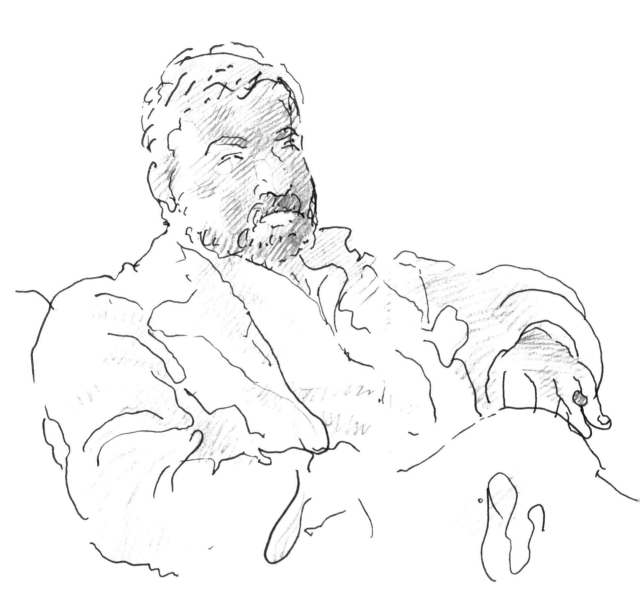

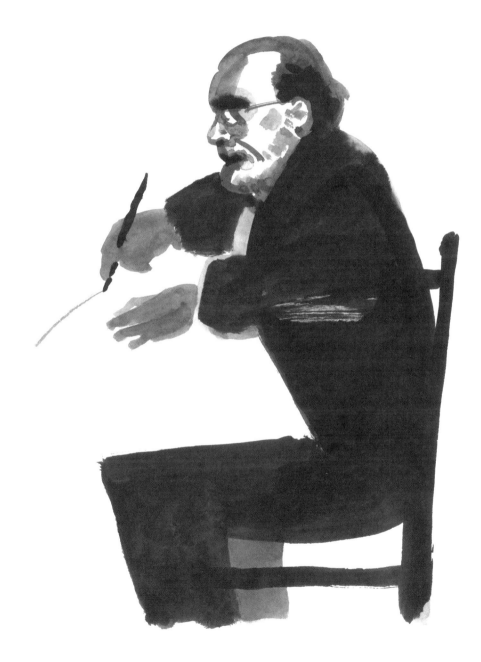

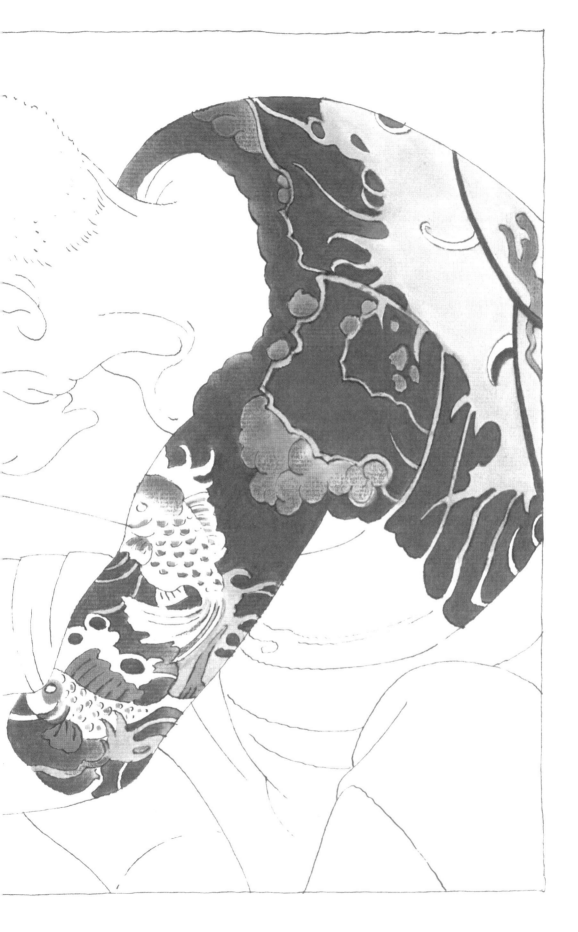

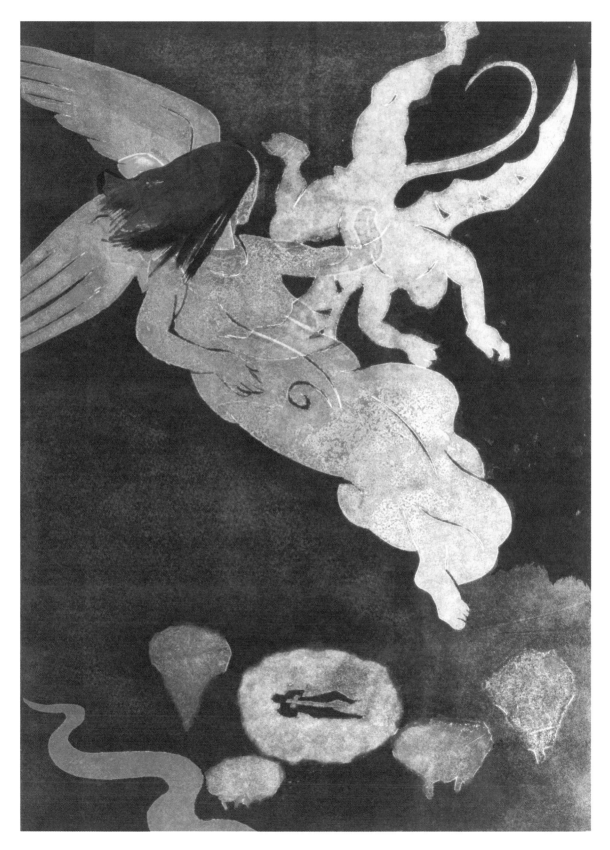

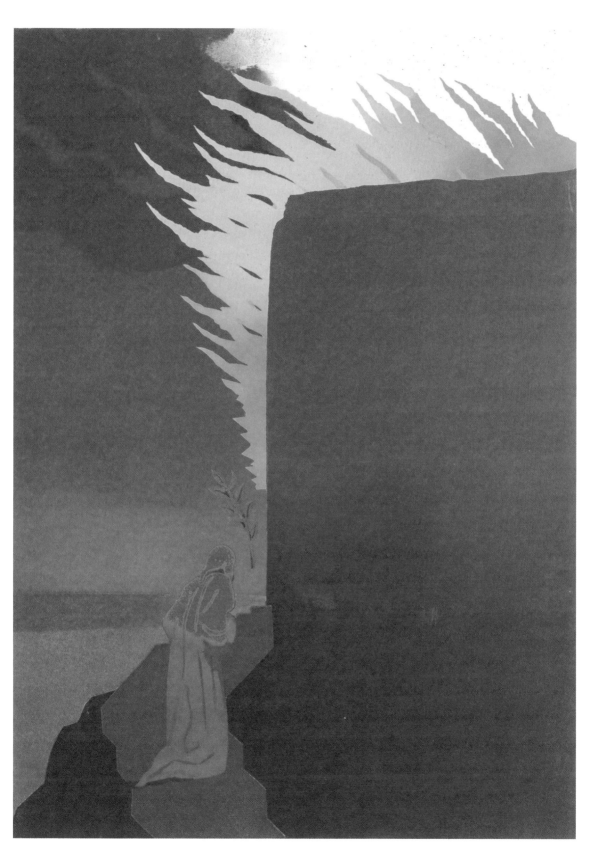

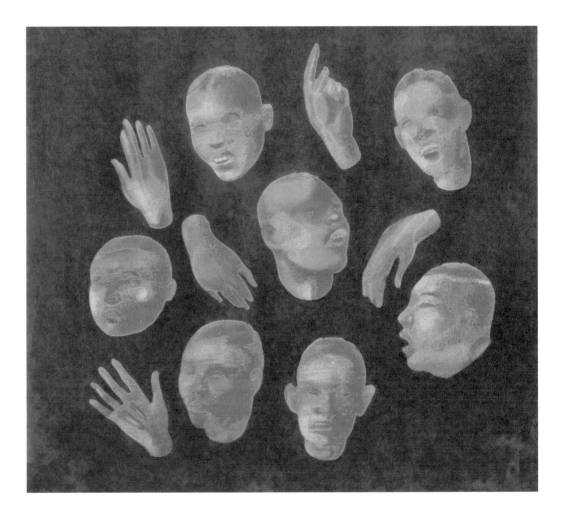

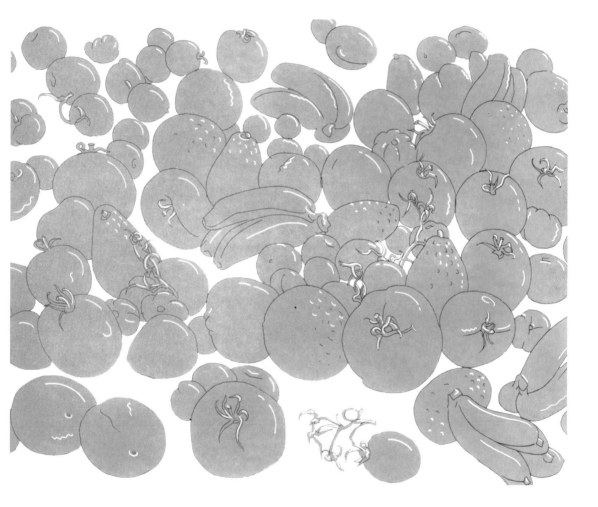

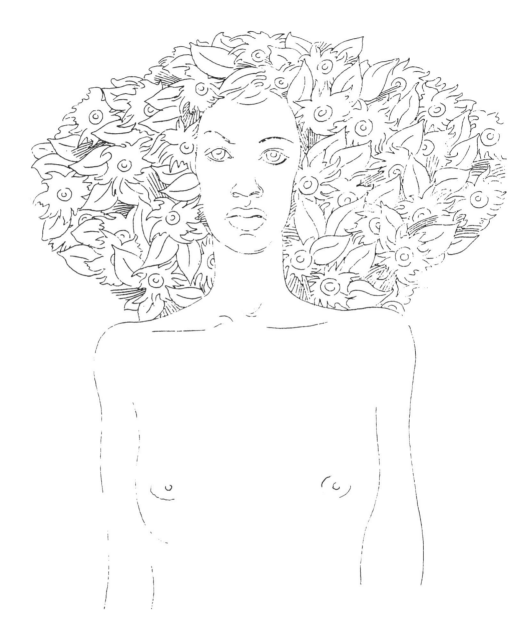

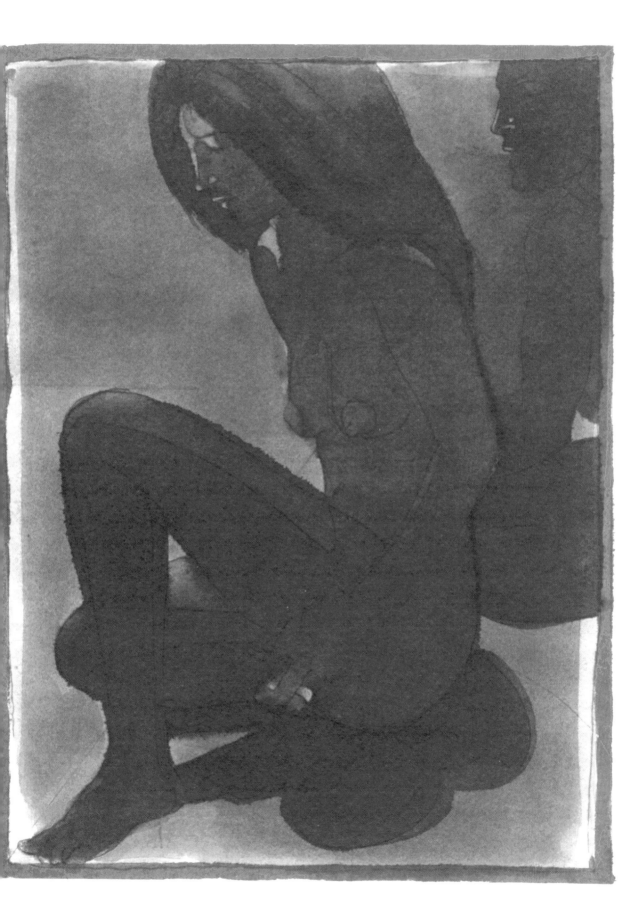

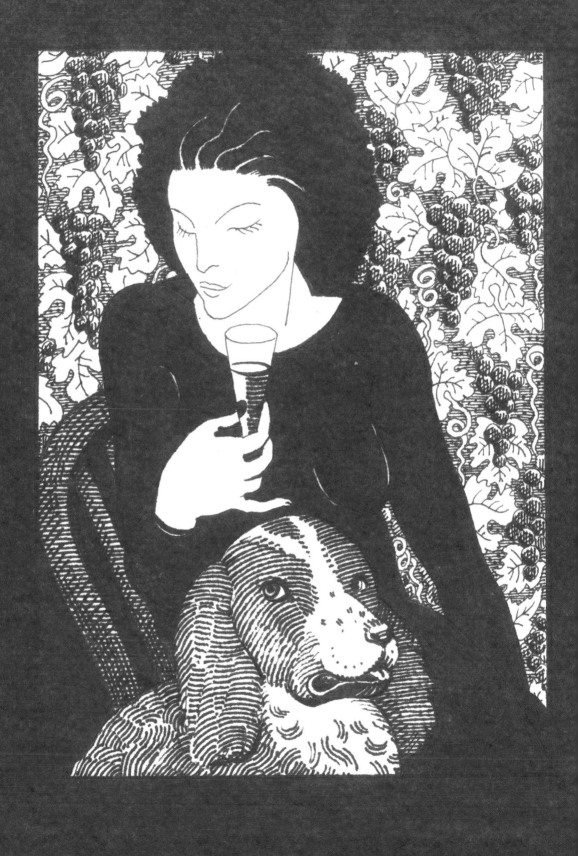

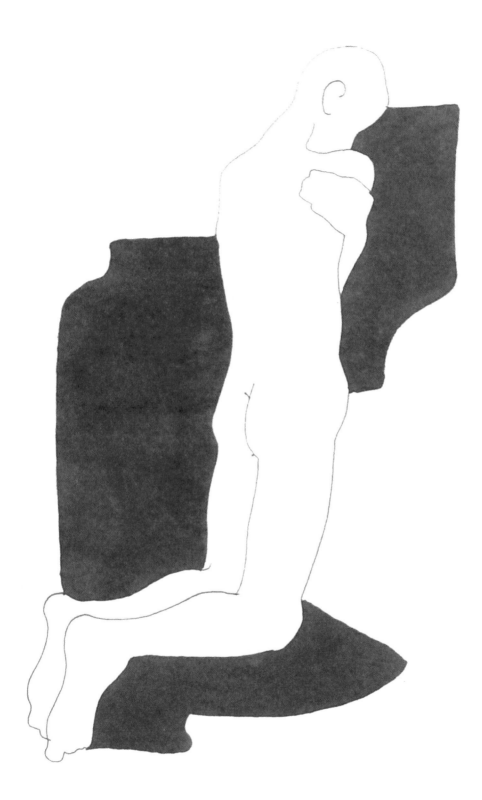

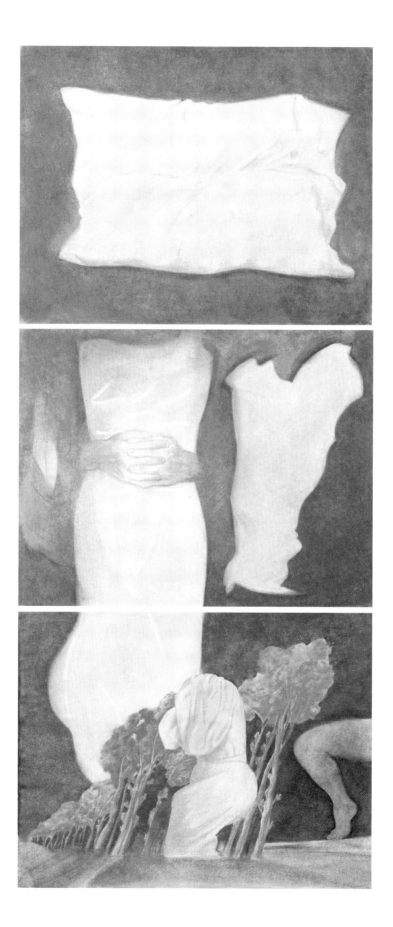

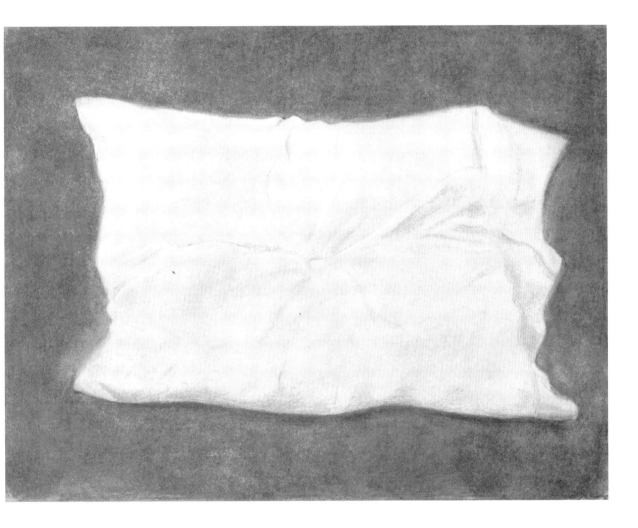

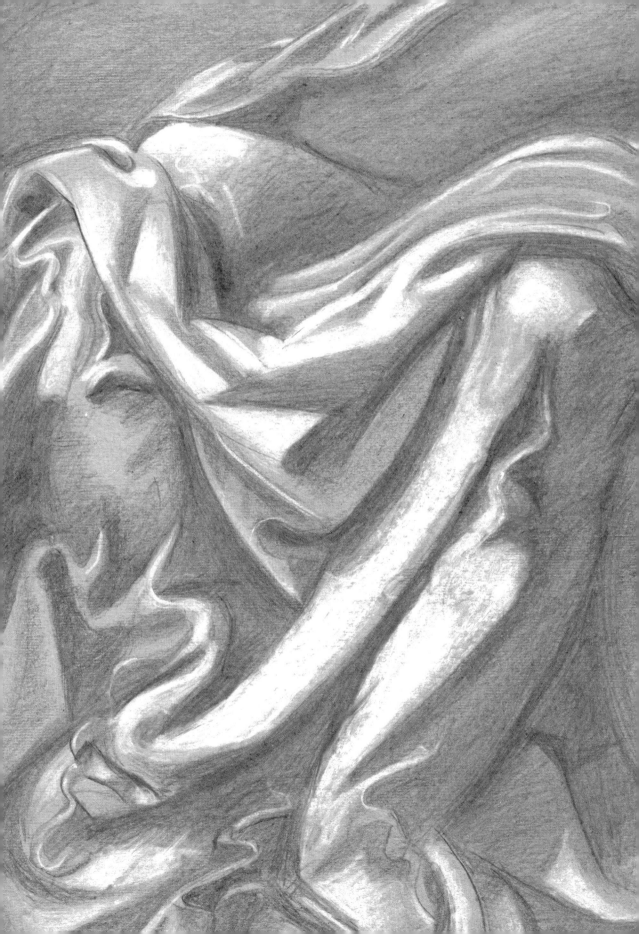

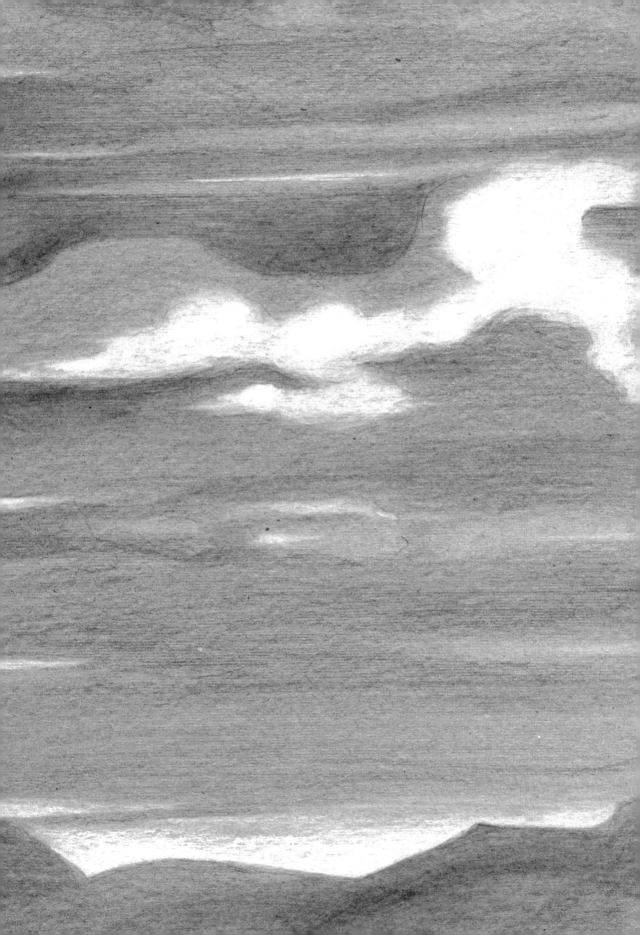

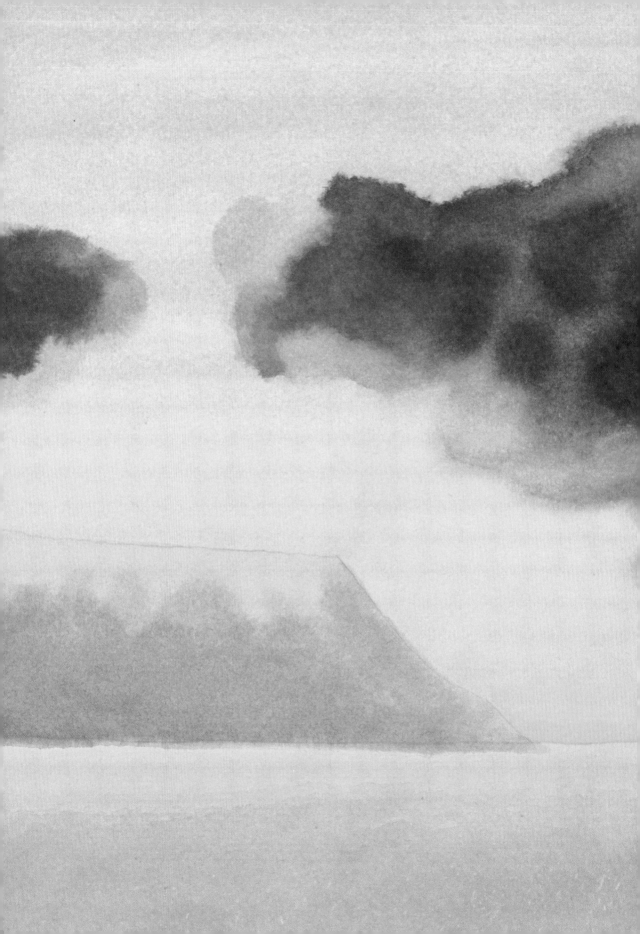

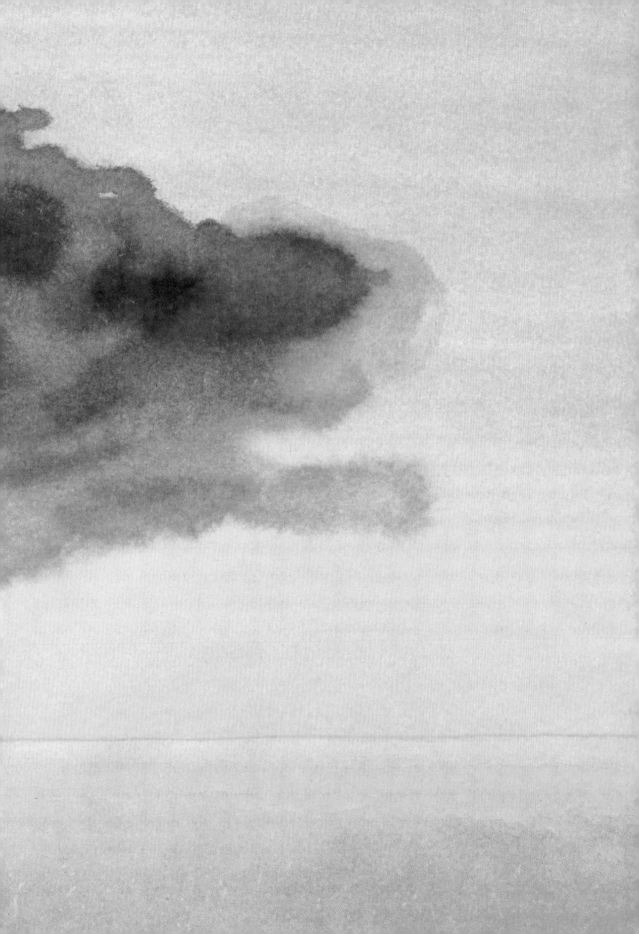

NOTES ON THE DRAWINGS

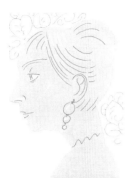

24. *Portrait Study*
Date: 2000
Medium: Pen and Ink
Size: 7 ½ x 11
Illustration of Freda for
**The Adventures of Chef
Gallois** by Yolla Bolly Press

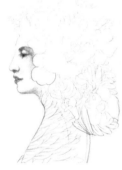

25. *Mother Nature*
Date: 1981
Medium: Pencil
Size: 14 ½ x 21
**Sketch for Spring Flower
Festival**

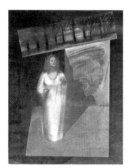

26. *Macbeth*
Date: 1993
Medium: Colored

Pencil and Collage
Size: 16 ¾ x 18
**Illustration for Barcelona
Opera Program**

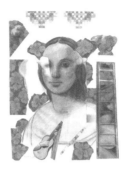

27. *Barber of Seville*
Date: 1993
Medium: Colored
Pencil and Collage
Size: 16 ¾ x 18
**Illustration for Barcelona
Opera Program**

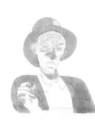

28. *Musician*
Date: 2002
Medium: Pen and
Colored Ink Wash
Size: 17 ¾ x 17 ¾
Tomato Records CD Cover

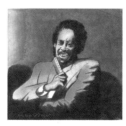

29. *Harmonica Player*
Date: 2001
Medium: Pen
and Marker with
Colored Ink
Size: 10 x 9 ½
Tomato Records CD Cover

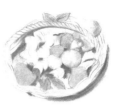

30. *Vegetable Basket*
Date: 1991
Medium: Colored
Pencil
Size: 18 x 24
**The Imaginary Life of
Claude Monet** Exhibition

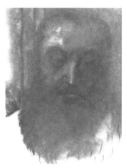

31. *Blue Head with Eyes
Closed*
Date: 1995
Medium: Colored
Pencil
Size: 9 x 12
**The Imaginary Life of
Claude Monet** Exhibition

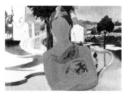

32. *Stranger in Piero
Landscape*
Date: 1990
Medium: Watercolor
Size: 23 ½ x 18
Works after Piero
Exhibition

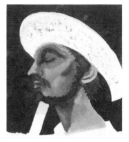

33. *Soldier from The
Resurrection*
Date: 1990
Medium: Watercolor
Size: 17 x 13 ¾
Works after Piero
Exhibition

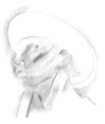

*Soldier from The
Resurrection*
Date: 1990
Medium: Colored
Pencil
Size: 17 x 13 ¾
Works after Piero
Exhibition

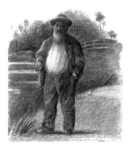

34. *Young Monet with
Japanese Bridge*
Date: 1991
Medium: Grease Pencil
Size: 9 x 10 ¾
**The Imaginary Life of
Claude Monet** Exhibition

35. *Monet's Couch*
Date: 1991
Medium: Colored Pencil
Size: 17 ½ x 14
The Imaginary Life of Claude Monet Exhibition

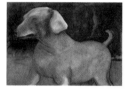

36. *Brown Dog Dreams of Black Man*
Date: 1992
Medium: Colored Pencil
Size: 21 x 15
The Imaginary Life of Claude Monet Exhibition

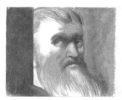

37. *Monet's Brown Head*
Date: 1991
Medium: Colored Pencil
Size: 22 ½ x 17 ¾
The Imaginary Life of Claude Monet Exhibition

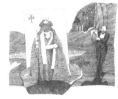

38. *Homage to Méliès*
Date: 1967
Medium: Pen and Ink

Size: 10 x 8 ½
Push Pin Graphic

39. *Woman and Fence*
Date: 1999
Medium: Monoprint
Size: 8 ½ x 10

Woman and Fence #2
Date: 1999
Medium: Monoprint
Size: 15 x 21 ¾

40. *The Victory of Heraclitus Over Chosroes*
Date: 1990
Medium: Brown Ink
Size: 23 ¼ x 18
Works after Piero Exhibition

41. *Soldier from The Victory of Heraclius over Chosroes*
Date: 1990
Medium: Colored Ink
Size: 17 x 14

Works after Piero Exhibition

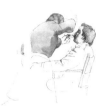

42. *Make Up Man*
Date: 1970
Medium: Pen and Ink, Colored washes
Size: 9 x 12
Dirk Bogarde on the set of **Death in Venice**

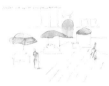

43. *Umbrellas*
Date: 1970
Medium: Pen and Ink and Colored Washes
Size: 12 x 9
On the set of **Death in Venice**

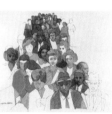

44. *Elevator Bank*
Date: 1965
Medium: Pen and Colored Ink
Size: 16 ¾ x 15
Illustration for **Fortune Magazine**

45. *Spanish Figures*
Date: 1985
Medium: Pen and Ink Wash
Size: 15 x 14

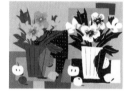

46. *Art and Learning*
Date: 1992
Medium: Silkscreen
Size: 23 x 17
For the Guggenheim Museum

47. *Flower Study*
Date: 1990
Medium: Colored Pencil
Size: 13 x 8
Birthday Card for Stony Brook University

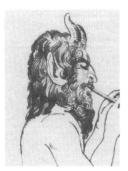

48. *Satyr*
Date: 1982
Medium: Pen and
Brown Ink
Size: 5 x 7 ½
Study for **Vanity Fair** cover

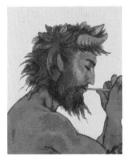

49. *Satyr in Color*
Date: 1982
Medium: Colored Ink
Size: 13 ¾ x 18
Study for **Vanity Fair** cover

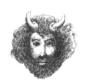

50. *Floating Devil Head*
Date: 1970s
Medium: Pen and Ink
Size: 10 x 13 ½
Study for Maysles' film
Gimmie Shelter

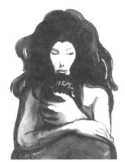

51. *The Embrace*
Date: 1972
Medium: Pen and Wash
Size: 5 ½ x 7
Drawing for French movie poster

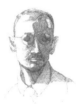

52. *Herman Hesse*
Date: 1974
Medium: Pen and Ink
Size: 7 ¼ x 8 ¾
Book Jacket for **Tales of a Student Life**

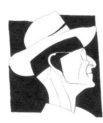

53. *Hermann Hesse*
Date: 1974
Medium: Pen and Ink
Size: 6 ½ x 7 ½
Sketch for Hermann Hesse Bookjacket

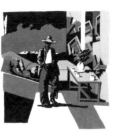

54. *Hermann Hesse*
Date: 1975
Medium: Pen, Ink, and
Celotak
Size: 14 x 14
Sketch for Hermann Hesse Calendar

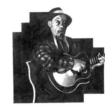

55. *Mississippi John Hurt*
Date: 1995
Medium: Pen and Ink
Size: 14 x 13
Tomato Records CD Cover

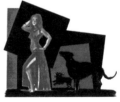

Red and Black
Date: 1998
Medium: Grease Pencil
Size: 23 x 17

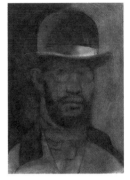

56. *An Ode To Toulouse
Lautrec*
Date: 2001
Medium: Crayon and
Colored Pencil
Size: 9 x 12 ¾
Poster for Paritux

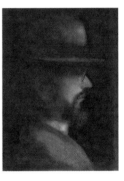

57. *Sketch 1 for An Ode to
Toulouse Lautrec*
Date: 2001
Medium: Crayon and
Colored Pencil
Size: 9 x 12
Poster for Paritux

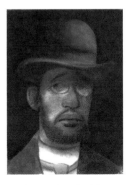

*Sketch 2 for An Ode to
Toulouse Lautrec*

Date: 2001
Medium: Crayon and
Colored Pencil
Size: 10 x 13 ¾
Poster for Paritux

58. *Olympia and Ollie*
Date: 1974
Medium: Silkscreen
Size: 23 x 17
After Manet

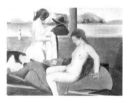

59. *Monet and Nudes*
Date: 1991
Medium: Colored
Pencil
Size: 23 x 17
**The Imaginary Life Of
Claude Monet** Exhibition

60. *Walter Davis Jr. at Piano*
Date: 1975
Medium: Pen and Ink
Size: 4 x 6

61. *Shirley Sleeping in
Woodstock*
Date: 1960
Medium: Crayon
Size: 9 x 6

62. *Rome 12 Noon*
Date: 1958
Medium: Pen and Ink
Size: 12 x 11

63. *Clouds and Shadows*
Date: 1990
Medium: Pen and Ink
Size: 10 x 8 ½
**Sketchbook Drawing View
from an Airplane**

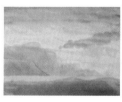

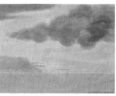

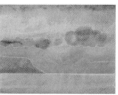

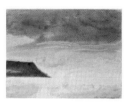

64. *Mexican Skies*
Date: 1985
Medium: Watercolor
Size: 8 ½ x 5
**Decorative Paintings for
the Aurora Restaurant**

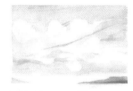

66. *Cloud Study*
Date: 1992
Medium: Colored
Pencil
Size: 9 x 12

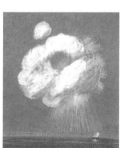

Cloud and Boat
Date: 1994
Medium: Crayon
Size: 9 x 12
**Study for Baudelaire's
Fleurs du Mal**

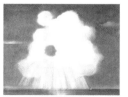

Cloud
Date: 1994
Medium: Crayon
Size: 12 x 8

Illustration for
Baudelaire's Fleurs
du Mal

67. *Cloud for Indonesia*
Date: 2006
Medium: Colored
Pencil
Size: 9 x 10
**Poster for Tsumnami
Relief**

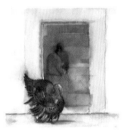

68. *Turkey Guarding Bar*
Date: 1989
Medium: Watercolor
Size: 14 x 19 ½
**At the entrance to the Bar
at Volpaia**

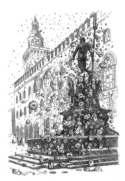

69. Flying Tortellini
Date: 1980
Medium: Pen and Ink
Size: 9 ¼ x 13
Piazza Nettuno, Bologna

70. *Prawns*
Date: 1995
Medium: Pen and Ink
Size: 10 X 7
**Sketchbook Drawing South
of France**

71. *Lobster*
Date: 1995
Medium: Crayon
Size: 7 X 10
**Sketchbook Drawing South
of France**

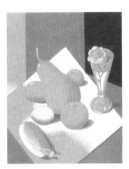

72. *Big Pear*
Date: 1990
Medium: Colored
Pencil
Size: 11 x 14
**Birthday Card for Stony
Brook**

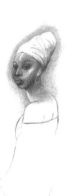

73. *Nina Simone*
Date: 2003
Medium: Colored
Pencil
Size: 9 x 16
Tomato Records **Lady Has
The Blues** CD cover

74. *Frightened Girl*
Date: 1965
Medium: Pen and Ink
Size: 8 x 8

75. *Angry Merchant*
Date: 1981
Medium: Brush
and Ink
Size: 18 x 24
Sketch for Signet Books
The Merchant of Venice

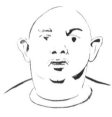

76. *Rudi*
Date: 1972
Medium: Brush and
Ink
Size: 16 x 15
Study for Book Jacket

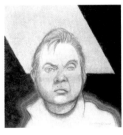

77. *Francis Bacon*
Date: 1997
Medium: Colored
Pencil
Size: 14 ½ x 15 ¼
New York Times **Review of
Books** Cover

78. *Portrait of Nina Simone*
Date: 2003
Medium: Colored
Pencil
Size: 16 x 16
Tomato Records **Lady Has
The Blues** CD cover

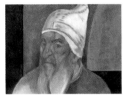

79. *Bad Pope*
Date: 1994
Medium: Colored
Pencil
Size: 24 x 18

80. *Grotesque Head*
Date: 1990
Medium: Magic Pencil
Size: 6 x 9

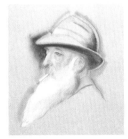

81. *Young Monet*
Date: 1991
Medium: Colored

Pencil on grey board
Size: 14 x 17
**The Imaginary Life of
Claude Monet** Exhibition

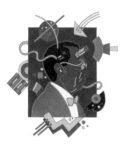

82. *Wassily Kandinsky*
Date: 1983
Medium: Marker and
Colored Ink
Size: 17 ½ x 21
**Sketch for Zanders Paper
Calendar**

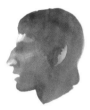

83. *Head Study*
Date: 1980
Medium: Colored Inks
Size: 6 x 9

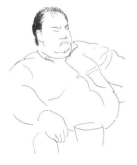

84. *Fat Man #1*
Date: 1995
Medium: Pen and Ink
Size: 7 X 10
London Sketchbook

85. *Fat Man #2*
Date: 2000
Medium: Pen and Ink
Size: 11 x 8
Sketch in hotel lobby

86. *Raven*
Date: 1975
Medium: Pen and Ink
Size: 12 ½ x 9 ½
Sketchbook Drawing

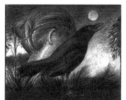

Shirley and Crow
Date: 1978
Medium: Grease Pencil
Size: 10 x 8 ¼

87. *Mozart 200*
Date: 1990
Medium: Ink and
Colored Pencil on

cardboard
Size: 14 ¾ x 20 ¾
**Metropolitan Opera and
Julliard Poster**

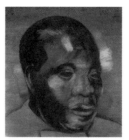

88. *For The Love of Louis*
Date: 1988
Medium: Colored
Pencil on board
Size: 10 ¾ x 13 ¼
**Poster for Louis
Armstrong at Carnegie
Hall**

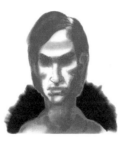

89. *Townes Van Zandt*
Date: 1985
Medium: Colored
Pencil
Size: 11 ¼ x 12 ¾
Poppy Records CD Cover

90. *Monet and Palette*
Date: 1991
Medium: Grease Pencil
Size: 17 ¾ x 24
**The Imaginary Life Of
Claude Monet** Exhibition

91. *Spanish Worker*
Date: 1970
Medium: Brush
and Ink
Size: 6 ½ x 9 ½
**Study for Book on the
Spanish Revolution**

92. *Nut Case*
Date: 1962
Medium: Pen Ink
and wash
Size: 6 x 6

Landscape 1
Date: 1998
Medium: Monoprint
Size: 21 ¾ x 15

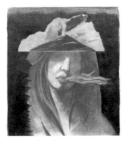

93. *Opera Singer*
Date: 1993
Medium: Colored
Pencil
Size: 16 ¾ x 18
**Illustration for Barcelona
Opera Program**

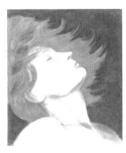

94. *Woman in Profile*
Date: 1998
Medium: Silkscreen
Size: 11 ¾ x 13

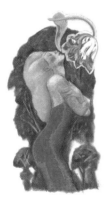

95. *Singer With Flower*
Date: 1996
Medium: Colored
Pencil
Size: 12 ¾ x 15 ¼
**Illustration for a Laguarda
Arts Poster**

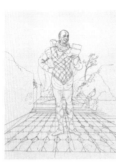

96. *Malvolio*
Date: 1983
Medium: Pen and
brown Ink
Size: 18 x 21 ½
**Twelfth Knight Sketch
for Penguin Books**

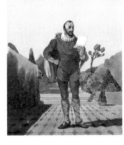

97. *Malvolio (in the Garden
Reading Letter)*
Date: 1983
Medium: Colored Inks
Size: 18 x 23 ¾
**Twelfth Knight Sketch
for Penguin Books**

98. *Lightening Studies*
Date: 1989
Medium: Pen and Ink
Size: 8 ¼ x 10 ¾,
(each box)

Studies for Julliard
Poster on Inspiration

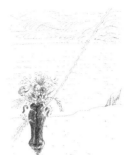

99. *Lightening Study with
Vase*
Date: 1989
Medium: Pen and Ink
Size: 8 ¼ x 10 ¾
**Studies for Julliard
Poster on Inspiration**

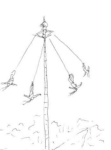

100. *Mexican Acrobats*
Date: 1990
Medium: Pen and Ink
Size: 9 x 12

101. *Pyramid*
Date: 1990
Medium: Pen and Ink
Size: 18 x 12

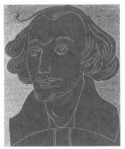

102. *Shakespeare*
Date: 2008
Medium: Pen and
Electronic Color
Size: 9 x 12
**Series for Theatre for a
New Audience**

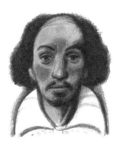

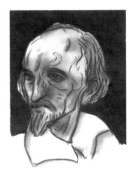

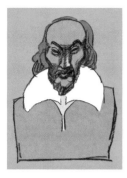

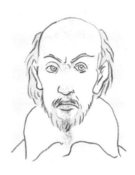

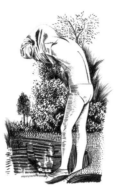

and Ink
Size: 24 x 17 ¾

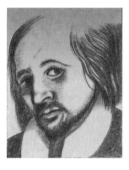

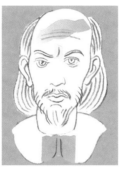

Sketch for Man Undressing
Date: 1990
Medium: Pen and Ink
Size: 17 ¾ x 23
Works after Piero
Exhibition

108. *Folon's Terrace in Monaco*
Date: 1987
Medium: Pen and Ink
Size: 12 x 9
Sketchbook Drawing

Antibes
Date: 1985
Medium: Pen and Ink
Size: 13 x 9 ¼
Sketch in the Garden of Daniele Giraudy

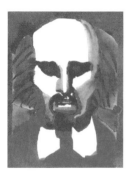

103. *Shakespeare Heads*
Date: 2001-2008
Medium: Watercolor, Pencil, Colored Pencil
Size: 9 x 12
Series for Theatre for a New Audience

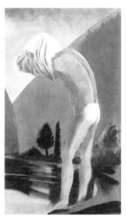

109. *Folon*
Date: 1987
Medium: Pen and Ink
Sketchbook Drawing
Size: 12 x 9

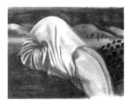

104. *Man Undressing*
Date: 1990
Medium: Watercolor and Colored Pencil
Size: 23 ¼ x 18
Works after Piero
Exhibition

105. *Man Undressing*
Date: 1990
Medium: Watercolor and Colored Pencil
Size: 18 x 23 ¼
Works after Piero
Exhibition

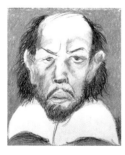

106. *Nudes*
Date: 1982
Medium: Brush

Georgio Soavi's Office at Olivetti
Date: 1986
Medium: Pen and Ink
Sketchbook Drawing
Size: 13 x 9 ¼

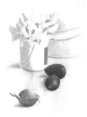

110. *Flowers and Shallot*
Date: 1995
Medium: Colored
Pencil
Size: 7 x 9
**Sketchbook Drawing
South of France**

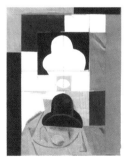

111. *Hotel Room*
Date: 1975
Medium: Pen and Ink
Size: 12 ½ x 9 ½
Book Illustration for
Cuisine of the Sun

113. *Portrait of Shirley*
Date: 1975
Medium: Pen and Ink
Size: 12 ½ x 9 ½
Book Illustration for
Cuisine of the Sun

114. *Radish Drawing*
Date: 1995
Medium: Colored
Pencil
Size: 10 x 7
**Sketchbook Drawing
South of France**

116. *Fez, View from Palais
Jamai*
Date: 1983
Medium: Brown Pen
and Ink
Size: 15 ½ x 7
**Sketchbook Drawing
from Morocco**

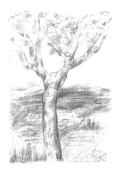

112. *Hats*
Date: 1990
Medium: Collage
Size: 9 x 12
After Picasso

118. *Blue Tree*
Date: 1995

Medium: Colored
Pencil
Size: 7 x 10
**Sketch of Mougins
Landscape**

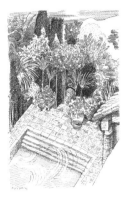

119. *Roger's Pool*
Date: 1995
Medium: Pen and Ink
Size: 7 x 10
**Sketchbook study at
Roger Vergés' House**

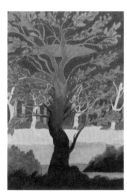

120. *Tree and Forest*
Date: 1985
Medium: Watercolor
Size: 14 x 17
Sketch for Wine Poster

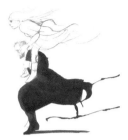

121. *Man and Witch*
Date: 1987
Medium: Brush
and Ink
Size: 9 x 12
**Gogol Endpapers, Tales
of St. Petersburg for
Olivetti**

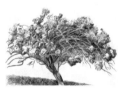

122. *Hydrangea*
Date: 1991
Medium: Colored
Pencil
Size: 24 x 17 ½

124. *Plant Drawing*
Date: 1960
Medium: Watercolor
Size: 15 ½ x 7

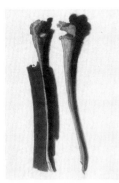

125. *Jack in the Pulpit*
Date: 1995
Medium: Watercolor
Size: 14 ¾ x 22

126. *Cheeses*
Date: 1975
Medium: Pen and Ink
Size: 11 x 8 ½
Drawing at Dinner Table in Milano

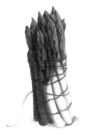

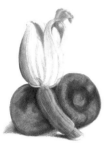

127. *Vegetables*
Date: 1995
Medium: Colored Pencil
Size: 7 x 10
Sketchbook Drawing South of France

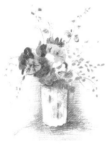

128. *Flower Drawing*
Date: 1995
Medium: Colored Pencil
Size: 5 x 7 ½

129. *Flowers in a Landscape*
Date: 1998
Medium: Blue Pencil
Size: 24 x 18

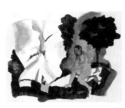

130. *Nude with Child and Schmata*
Date: 1967
Medium: India Ink on Paper
Size: 20 x 19
Drawing after La Tempesta

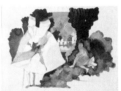

Nude with Child and Schmata #2
Date: 1967
Medium: India Ink on Paper
Size: 20 x 19
Drawing after La Tempesta

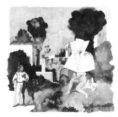

131. *La Tempesta with Schmata*
Date: 1967
Medium: India Ink on Paper
Size: 18 x 17
Drawing after La Tempesta

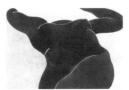

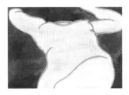

132. *Foreshortened Nudes*
Date: 1976
Medium: Watercolor
Size: 10 ½ x 8
Poster Studies

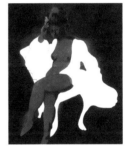

133. *Nude In Chair*
Date: 1968
Medium: Brown and Black Ink
Size: 13 ¼ x 16 ¾

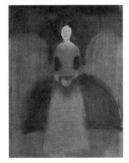

134. *Dark Angel*
Date: 1965
Medium: Black Ink
Size: 18 ½ x 23 ¾

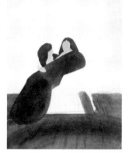

135. *Two Dark Ladies*
Date: 1965
Medium: Black Ink
Size: 18 x 22 ½

136. *George Gershwin*
Date: 1996
Medium: Colored
Pencil
Size: 21 x 15
**Illustration for the New
York Times**

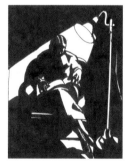

137. *Woman Reading*
Date: 1983
Medium: Pen, brush,
and Ink
Size: 9 x 10 ¼
**Call for Entries AIGA
Bookshow**

Woman Reading Study
Date: 1983
Medium: Pen, brush,
and Ink
Size: 11 ¼ x 13 ¾
**Call for Entries AIGA
Bookshow**

138. *Dining*
Date: 1979
Medium: Pen and Ink
Size: 12 ½ x 8
**From Pavillion Du Lac,
Paris**

*Spoiled Child at
Piero's*
Date: 1990
Medium: Pen and Ink
Size: 10 x 8
From Radda in Chianti

139. *Dining*
Date: 1987
Medium: Pen and Ink
Size: 10 ½ x 8 ½

**Sketchbook Drawing
from Miramonte Burgess
Cellers Cabernet**

Eating Crab
Date: 1989
Medium: Pen and Ink
Size: 10 x 8
**Sketchbook Drawing
while Dining in Hawaii**

140. *Sisters*
Date: 1985
Medium: Pen and Ink
Size: 13 x 9
**The Pool at the
Colombe d'Or**

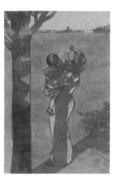

142. *Landscape with
Woman and Child*
Date: 1982
Medium: Watercolor
Size: 11 ½ x 17 ½

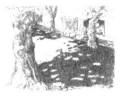

143. *Trees and Shadows*
Date: 1980
Medium: Pen and Ink
Size: 10 ½ x 8 ½
**Sketchbook Drawing
South of France**

144. *Garden*
Date: 1985
Medium: Pen and Ink
Size: 18 x 23 ¾
Conran Anniversary Print

146. *Monet Finds his Cat*
Date: 1993
Medium: Lithograph
Size: 17 x 12 ½
**The Imaginary Life of
Claude Monet** Exhibition

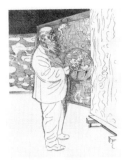

147. *Monet and Palate*
Date: 1993
Medium: Brown Pen
and Ink
Size: 6 x 9
**The Imaginary Life of
Claude Monet** Exhibition

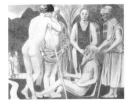

148. *The Death of Noah*
Date: 1991
Medium: Watercolor
and Red Grease
Pencil
Size: 23 ¼ x 18
Works after Piero
Exhibition

149. *Nude Study*
Date: 1991
Medium: Colored
Pencil
Size: 7 ½ x 15 ½
Works after Piero
Exhibition

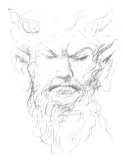

150. *Bathers at Brera*
Date: 1975
Medium: Silkscreen
Size: 22 ½ x 17 ½
**Pinacoteca Brera
Museum Benefit**

151. *Bathers at Brera*
(detail)

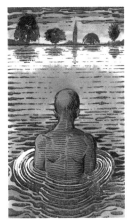

152. *Swimmer*
Date: 1982
Medium: Brush, Ink,

and Watercolor
Size: 5 ¼ x 9 ½
Theatre Poster Study

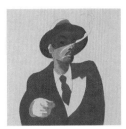

153. *Devil Doodle*
Date: 1995
Medium: Pencil
Size: 8 x 11

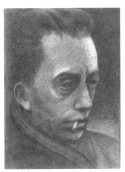

154. *Camus Study 1*
Date: 2003
Medium: Colored
Pencil
Size: 10 x 12
**School of Visual Arts
Poster**

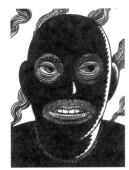

Camus Study 2
Date: 2003
Medium: Colored

Pencil
Size: 5 ½ x 9
**School of Visual Arts
Poster**

155. *Man Smoking*
Date: 1980
Medium: Brown Ink
Size: 13 x 16
**Drawing for Fiorello's
Restaurant**

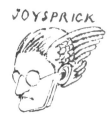

156. *Masked Man*
Date: 1992
Medium: Brush
and Ink
Size: 6 x 9 ½
**Cover for Book on
Terrorism**

157. *James Joyce*
Date: 1973
Medium: Brush
and Ink
Size: 9 x 10
Joysprick Book Cover

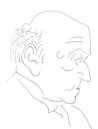

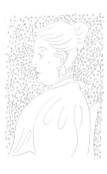

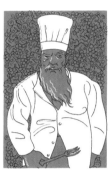

158. *The Great Wine Authority*
Date: 1992
Medium: Pen and Ink
Size: 5 ½ x 8 ½
Sketchbook Drawing

Portrait Study
Date: 2000
Medium: Pen and Ink
Size: 7 ½ x 11
Illustration of the Baroness from **The Adventures of Chef Gallois**

161. *Portrait Study*
Date: 2000
Medium: Color print
Size: 6 ½ x 9 ½
Illustration of Francois from **The Adventures of Chef Gallois**

164. *The Dance*
Date: 2005
Medium: Silkscreen
Size: 12 x 16
Print for the Rubin Museum

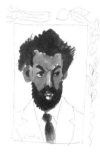

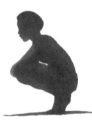

159. *Florentine Gentleman Eating Alone*
Date: 1990
Medium: Pen and Ink
Size: 10 x 8
Sketchbook Drawing

Portrait Study
Date: 2000
Medium: Pen and Ink
Size: 7 ½ x 11
Illustration of Otto for **The Adventures of Chef Gallois**

162. *Jazz Musicians and Flowers*
Date: 1975
Medium: Silkscreen
Size: 18 x 12
Illustration for Jazz After Six

165. *Figure in Profile*
Date: 2000
Medium: Watercolor
Size: 18 x 22
Illustration for School of Visual Arts Poster

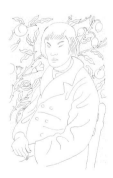

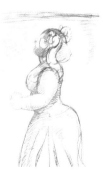

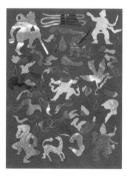

160. *Portrait Study*
Date: 2000
Medium: Pen and Ink
Size: 7 ½ x 11
Illustration of Pom-Pom from **The Adventures of Chef Gallois**

Portrait Study
Date: 2000
Medium: Pen and Ink
Size: 7 ½ x 11
Illustration for **The**

163. *Sax and Singer*
Date: 1976
Medium: Pencil
Size: 17 ¾ x 24
Study for New Orleans Jazz and Heritage Poster

166. *Appliquè*
Date: 2005
Medium: Silkscreen
Size: 12 x 16
Print for the Rubin Museum

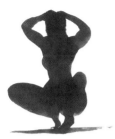

167. *Figure with Hands on Head*
Date: 2000
Medium: Watercolor
Size: 23 x 17 ¾
Illustration for School of Visual Arts Poster

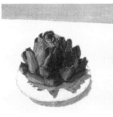

168. *Artichoke*
Date: 1968
Medium: Pen, Ink, and Watercolor
Size: 7 ¾ x 7

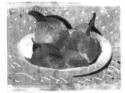

169. *Fruit Bowl*
Date: 1998
Medium: Monoprint
Size: 14 ¾ x 10 ¾

170, 171. *Sketches and Finished Drawings*
Date: 1971
Medium: Pen, Ink, and Wash
Size: 21 x 15 ½
Illustration from
Annotated Don Juan by
Isaac Asimov

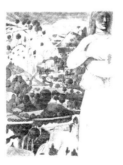

172. *Angel and Landscape from The Nativity*
Date: 1990
Medium: Pen and Ink
Size: 17 ¾ x 23 ¼
Works after Piero
Exhibition

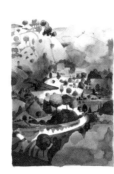

173. *Landscape from The Nativity*
Date: 1990
Medium: Watercolor
Size: 15 ¾ x 22
Works after Piero
Exhibition

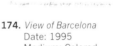

174. *View of Barcelona*
Date: 1995
Medium: Colored Pencil
Size: 9 x 6

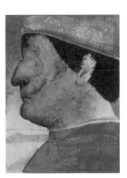

176. *Battista and Federico*
Date: 1990
Medium: Colored Ink
Size: 23 x 19 ¼
Works after Piero
Exhibition

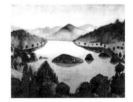

Landscape from the Triumph of Federico da Montefeltro
Date: 1990
Medium: Watercolor
Works after Piero
Exhibition
Size: 23 ½ x 18

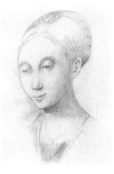

177. *Hand Maiden*
Date: 1990
Medium: Colored Pencil
Size: 23 x 18
Works after Piero
Exhibition

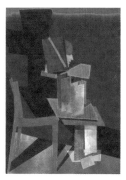

178. *Seated Woman*
Date: 2000
Medium: Collage
Size: 10 x 13
Heller Chair Poster proposal

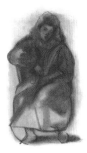

179. *Brown and Blue Woman*
Date: 1990
Medium: Colored Pencil
Size: 15 x 22
Heller Chair Poster Proposal

180. *Pool House*
Date: 1989
Medium: Pen and Ink
Size: 10 x 7
Sketchbook Drawing at Roger Vergés' House

181. *Window*
Date: 1979
Medium: Pen and Ink
Size: 10 ½ x 8 ¼
Italian Sketchbook

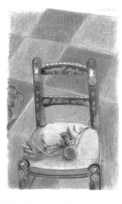

182. *Chair and Fruit*
Date: 1995
Medium: Colored Pencil
Size: 7 x 10
Sketchbook Drawing from the South of France

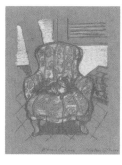

183. *Annie in Chair*
Date: 1995
Medium: Silkscreen
Size: 8 ½ x 11
Yearend Greeting

184. *Small Hotel Room*
Date: 1995
Medium: Pen and Ink
Size: 14 x 10
Sketchbook Drawing

Georgio's Livingroom
Date: 1970
Medium: Pen and Ink
Size: 11 x 8 ½
Italian Sketchbook

185. *The Sea of Luggage*
Date: 1992
Medium: Pen and Ink
Size: 11 x 8 ½
London Sketchbook

Fortuni Museum
Date: 1985
Medium: Pen and Ink
Size: 9 x 7
Venice Sketchbook

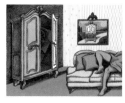

186. *Armoire*
Date: 2005
Medium: Lithograph
Size: 15 ½ x 12
Print for a Furniture Company

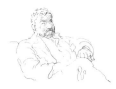

188. *Jivan*
Date: 1987
Medium: Pen and Ink with Colored Pencil
Size: 10 ½ x 8
Sketchbook Drawing California

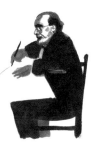

189. *Man Drawing*
Date: 1988
Medium: Brush and Ink
Size: 7 x 9
Book Jacket Portrait

190. *Tattoo*
Date: 1980
Medium: Ink and

Watercolor
Size: 19 ¼ x 16
**Illustration for the Art
Director's Club, KS City**

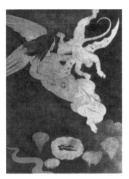

192. *Canto V*
Date: 1999
Medium: Monoprint
Size: 11 ½ x 15 ½
**Illustration for Dante's
La Divina Commedia
Purgatorio**

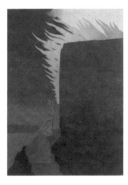

193. *Canto XXV*
Date: 1999
Medium: Monoprint
Size: 11 ½ x 15 ½
**Illustration for Dante's
La Divina Commedia
Purgatorio**

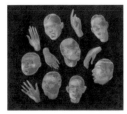

194. *Jazz Heads and Hands*
Date: 1974
Medium: Watercolor

and Ink
Size: 14 x 13
**Album Art for Tomato
Records**

195. *Fruits*
Date: 2000
Medium: Lithograph
Size: 23 x 17 ½
End Paper for **The
Adventures of Chef
Gallois**

196. *Nude and Eyes*
Date: 1996
Medium: Pen and Ink
Size: 6 x 8
**Exhibition
Announcement for
Nuages Gallery, Milano**

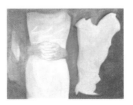

197. *Dark Nude*
Date: 1987
Medium: Watercolor
Size: 7 ¼ x 9 ¼
Illustration from **J'Irai
Cracher Sur Vos Tombes**
by Boris Vian

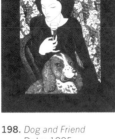

198. *Dog and Friend*
Date: 1995
Medium: Pen and Ink
Size: 8 ¼ x 10 3/8
Bookplate

199. *Kneeling Nude*
Date: 1970
Medium: Pen and
Brushed Ink
Size: 9 x 12

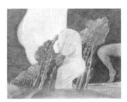

200. *Triptych*
Date: 2005
Medium: Colored
Pencil
Size: 24 x 18
**For Desire Submerged
Exhibition at Gallery 138**

201. *Pillow (detail)*

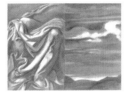

202. *Drapery and Clouds*
Date: 2005
Medium: Colored
Pencil on board
Size: 21 x 15
**After Leonardo da Vinci
for Gallery 138**

204. *Purple Cloud*
Date: 1994
Medium: Colored Ink
Size: 24 x 18
**Mexican Sky Series for
the Aurora Restaurant**